IMAGES
of Aviation

PAINE FIELD

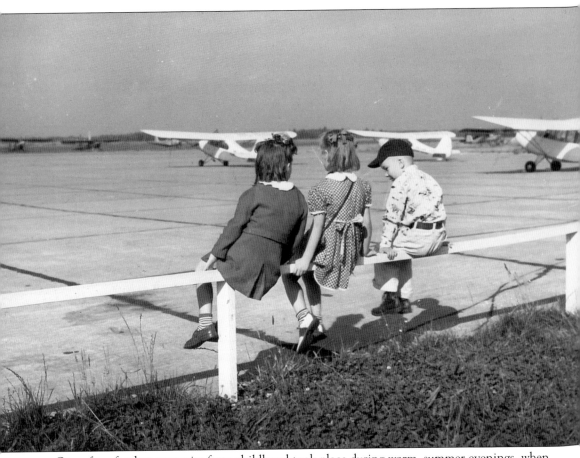

One of my fondest memories from childhood took place during warm, summer evenings, when my father came home from his job at Boeing. He would grab a bite to eat, then invite me to help him in the vegetable garden. By then, it was usually dark. Stars twinkled in the sky. We would root around in the garden by moonlight, pulling weeds, raking the soil, and picking vegetables that had ripened. Because of our close proximity to Paine Field Airport, it was not uncommon to see planes. My father would lean on his shovel and point out the various airplanes, from small Cessnas to large commercial jetliners, that rumbled through the night. It is a cherished memory: a boy and his father contemplating things beyond a human's reach. (Courtesy of the Everett Public Library.)

ON THE COVER: The 1944 photograph shows enlisted reserves during World War II inspecting a weather-scarred US Army Air Corps AT-6 aircraft (now called a T-6) at Paine Field. (Courtesy of the Everett Public Library.)

IMAGES
of Aviation

PAINE FIELD

Steve K. Bertrand

ARCADIA
PUBLISHING

Published by Arcadia Publishing
Charleston, South Carolina

Printed in the United States of America

Library of Congress Control Number: 2013948723

For all general information, please contact Arcadia Publishing:
Telephone 843-853-2070
Fax 843-853-0044
E-mail sales@arcadiapublishing.com
For customer service and orders:
Toll-Free 1-888-313-2665

Visit us on the Internet at www.arcadiapublishing.com

For my father and mother, Daniel Hart and Jeanette Lura Bertrand,
who instilled a love for flying when we were growing up, through
travel and numerous Paine Field Air Shows, and those who
embrace the skies by proclaiming, "O! for a horse with wings!"

CONTENTS

ACKNOWLEDGMENTS

This book would not have come to fruition without the numerous individuals who provided facts, stories, and photographs. Their time, efforts, and expertise are very much appreciated. Through these contributions, it was possible to piece together the 77-year history of Paine Field.

I wish to thank Sgt. Samuel D. Harris of Everett's Air Force Recruiting office; Nona Anderson, Jennifer Eckman, Sandy Johnson, Bill Dolan, Bruce Goetz, and David Waggoner of the Snohomish County Airport; Rod Devol, Paine Field Airport historian; Justin Best of the *Everett Herald*; Sue Bradley, Boeing's director of communications; Sara Bruestle of the *Mukilteo Beacon*; Michael Cachi of Giclee Prints; Maj. Mark Norton of Civil Air Patrol (Paine Field Squadron); Ann Collier of the Mukilteo Historical Society; Ed Kaplanian, Melody Meyers, and Sandy Ward of the Future of Flight Aviation Center and Boeing Tour; Barbara George and Kim David of the Snohomish County Museum of History; Diane M. Janes and Steven B. Gobin of the Tulalip Tribes; Susan Goff of the Washington State Department of Archaeology and Historic Preservation; Elaine Garcia of the Everett School District; David Dilgard, Melinda Van Wingen, and Lisa Labovitch of the Everett Public Library; Synthia Santos of the Lewis Army Museum; M.Sgt. Ray Jordan of the McChord Air Museum; Melissa Parr of the Hibulb Cultural Center; Richard A. White of the Boeing Company; Mike Lombardi of the Boeing Historical Services; Paul Allen, Cory Graff, and Mari Haug of the Flying Heritage Collection; John T. Sessions and Vanessa Dunn of the Historic Flight Foundation; Ted Huetter, Katherine Williams, Amy Heibrick, and Janice Baker of the Museum of Flight; Carolyn Marr of the Museum of History and Industry; Eric Minnig of Ken's Camera; Fred Poyner of the Washington State Historical Society; Robert B. Hood of the Seattle Museum of Flight; Jim Larsen of Aero Acoustics, Inc.; Shana Smith of the Poulsbo Historical Society; Ken and Ethel Cage of the Marysville Historical Society; Terry Wilcoxson of Castle and Cooke Aviation; Nicolette Bromberg of the University of Washington (Special Collections); Commander Matthew J. Kennedy, USN; and Rebecca Coffey and David Mandel of Arcadia Publishing.

In addition, I would like to thank Neil Anderson, Don Bakken, my wife, Donna Marie Bertrand, Patrick Bertrand, Phil Bertrand, Jeff Bohnet, Dick Brooks, Bruce B. Brown, Bill Canavan, Dave Clark, Bob Crump, Audrey Dannar, Beverly (Dudder) Ellis, Gary Evans, Eric Frommer, Max Grinell, George Haage, Brian Hawkins, William Hull, Glenn C. Humann, David Jackson, Peter Jackson, Peter Jensen, Steve Kerber, Pete Kinch, Paul Lasher, John Moberg, Rodney Neff, Jack and Larry O'Donnell, George Petrie, Bob Potenza, Joe Ramsdell, Bob Reith, Ron Reardon, Margaret Riddle, Lyle Ryan, Rick Shea, Chuck Smith, Matt Stevens, Norm Story, Christopher Summit, Dr. Matt Thomas, Art Unruh, Joy Webber, Brad Widrig, John Wolcott, and Ron Ziegler.

INTRODUCTION

Paine Field was funded and built by the Works Progress Administration (WPA) in 1936. By 1939, aircraft were flying from the airport. Originally intended as a commercial airport for Snohomish County, plans changed during World War II (1941–1945), when the site became a military airport. The military would again occupy Paine Field during the Korean conflict. At this time, Paine Field saw both commercial and military involvement. It was not until Snohomish County took full control of the airport in the mid-1960s that new commercial development emerged. The arrival of Boeing in 1966 had a huge economic impact on the local community and aviation commerce.

Throughout its history, Paine Field has been an important hub for general aviation and such businesses as B.F. Goodrich Aerospace, Crown Aviation, and Precision Engines. Today, Paine Field is managed by Snohomish County. Located between Mukilteo and Everett, Paine Field (previously Everett Army Airport) was renamed in 1941 to honor a local Air Corps pilot, 2nd Lt. Topliff Olin Paine (1893–1922), a veteran of World War I.

The building of Paine Field, originally called Snohomish County Airport, proved one of the largest local relief projects of the Great Depression. Planned by the US Department of Commerce and the WPA, the goal of the project was to provide jobs in the Pacific Northwest and to build a first-class airport. It was pioneer Northwest aviator Elliott Merrill (1901–1992) who first recommended the site. Merrill Ring Logging and the Pope & Talbot Company owned the 640 acres. Located seventeen miles north of Seattle and eight miles southeast of Everett, the unpopulated location had a reputation of being fog-free. At an elevation of 606 feet, Paine Field lies on a direct route from Portland, Seattle, Vancouver, BC, and Alaska. With Snohomish County matching federal dollars, the work phase began with 300 workers clearing the land. A well provided water for locomotives. Temporary buildings were constructed on skids and moved as the work progressed. At its completion, the Snohomish County Airport had four runways.

World War II would change both the name of the airport and its purpose. In the spring of 1941, the first Army Air Corps arrived. The purpose was to protect Seattle's Boeing plant, Bremerton Shipyards, and King County Municipal Airport, home of B-17s and B-29s. At the time, the site was referred to as the Everett Army Airport. It was soon renamed Paine Field. The Air Corps involvement at Paine Field lasted the duration of World War II. It constructed the first control tower at Paine Field, near the Army hangar. Some military personnel remained until 1948. While at Paine Field, the Air Corps made many improvements, including buildings, lighting, and runways. It also constructed aviation fuel storage units used by World War II aircraft, including the B-26.

The late 1940s saw the arrival of Alaska Airlines, which established a maintenance and repair service at Paine Field, and Willard Flying Service, which provided air-taxi and flight-training services. From 1946 to 1969, Willard operated at Paine Field. With a decrease in military involvement at Paine Field following World War II, the dream of a county airport again emerged. By 1946, the airport's operations were gradually returned to Snohomish County. During this time, Island Airways operated at Paine Field (1947–1948). However, with the emergence of the

Korean conflict in 1951, plans changed. Following the Air Force's arrival, the military portion of Paine Field was referred to as Paine Air Force Base. Most of the county facilities were turned over to the Air Force, including the reintroduction of the use of the control tower. However, a "shared use" agreement existed; for example, the county rented to businesses like Alaska Airlines. This agreement lasted from 1951 to 1968. A critical Western Defense Command base, Paine Air Force Base was an "alert-status" military facility that housed jet interceptors and tactical radar installations. First-generation jets such as the F-89c were stationed at the base. During the 1960s, the F-102 and F-106 arrived.

The Air Force left Paine Field in 1968. This was due to missiles replacing bombers. With the change in threats, Air Defense Command units were terminated. The door was once again open for the construction of a regional airport and/or to expand economic interests. With the arrival of Boeing in 1966, a major direction for Paine Field was determined. Plans included improving Snohomish County Airport. Both Paine Field and Boeing were thriving by the 1970s, and general aviation activity reached its peak. However, when the topic of establishing a commercial air-carrier airport at Paine Field surfaced, local citizenry protested. The major issues cited were reduced personal safety, increased noise, and property devaluation.

In recent times, local residents and businesses surrounding Paine Field have raised concerns over expansion. Their concerns have to do with the impact on quality of life. A citizen group, Save Our Communities (SOC), has emerged to thwart commercial airline development. They do not want to see the area become a "Sea-Tac North." This has been prompted by the fact that both Allegiance Airlines and Horizon Airlines expressed an interest in establishing domestic flights at Paine Field. Others do not see airport expansion as a problem. A group called Fly From Everett feels that the benefits outweigh the negatives. Though communities such as Edmonds, Lynnwood, Mountlake Terrace, Woodway, and Mukilteo oppose commercial flights, Fly From Everett says there would be benefits for Snohomish County.

Events since the turn of the new millennium include a new tower at Paine Field, installed to improve visibility. It is located near the Snohomish County Airport office. The biggest misconception by the public regarding the airport is that it is simply a Boeing airport. The truth is, Boeing is the largest tenant of Snohomish County Airport. Located within the city of Everett, Boeing employs 42,000 people in staggered shifts. Recently, Paine Field has become a popular tourist destination. With attractions such as The Legend Flyers (Me262 Project), living museums like Paul Allen's Flying Heritage Collection and John Sessions's Historic Flight Foundation, the Museum of Flight Restoration Center, and the Future of Flight and Boeing's Tour Center, people flock to Snohomish County's largest employer, Paine Field. In addition, Snohomish County Airport facilities and other major employers provide over 30,000 jobs and houses more than 50 different businesses. A single aviation company at Paine Field impacts four times as many businesses in the local community. And the good news is that aviation opportunities continue to grow.

Considered a "regional service" airport, Paine Field is viewed by the federal government as a "reliever" airport. On average, it has over 10,000 passenger boardings each year. Home to 615 aircraft, the airport has a $19.8 billion economic impact on the region and state. Airport business provides $79 million in tax revenues to local and state government. Paine Field operates in class "D" airspace, which means that pilots need to maintain contact with the tower when entering the airport's airspace (2,500 feet or below, and/or within its five-mile radius).

The evolution of Paine Field's Snohomish County Airport has been a long, slow process spanning decades. Obviously, the blueprint for Paine Field is different today than first envisioned in the 1930s. It has gradually been influenced over time by the economy, technological advances, and the needs of the community. In addition, the key role of general aviation cannot be overlooked. As a result, through the dreams of many, it has come a first-rate airport. Paine Field's various businesses have not only provided jobs and boosted the local economy, but they have helped shape the aviation industry throughout the world.

One

WPA Years

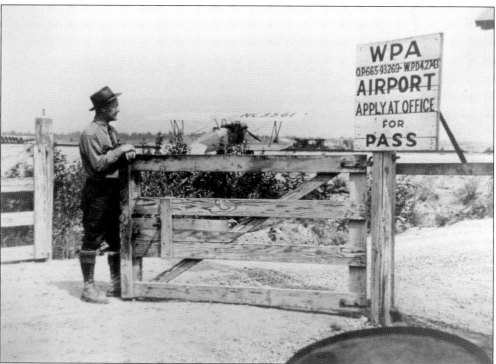

Paine Field, known as the Snohomish County Airport, is located six miles from the city of Everett in Western Washington. For a regional airport, Paine Field offers a unique history. Spawned by the Commerce Department and the local Works Progress Administration (WPA) in the aftermath of the Great Depression, the airport was intended to spur economic growth and create jobs in the region. It was to become one of 10 new "Super Airports" in the United States. Pictured here is W.D. Hewitt, construction superintendent, at the site of the future Snohomish County Airport in 1936. (Courtesy of the Everett Public Library.)

Hundreds of airports were created throughout the United States during the mid-1930s. As part of a federally funded WPA project, this program offered work and new airports. The WPA projects helped improve many of the existing and potential airports throughout America; but it was the Air Commerce Act of 1926 that created airport funding. (Author's collection.)

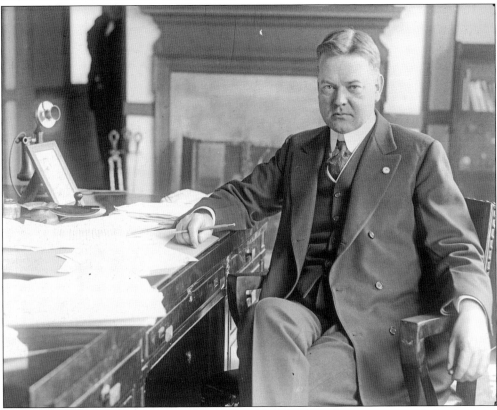

In the early 20th century, many aviation leaders felt federal regulations were needed to improve the public's confidence in air transportation. As a result, the Air Commerce Act became law on May 20, 1926. Their focus was to ensure civil air safety. Opponents felt the federal government had no responsibility for developing civil airports. Herbert Hoover (pictured), then secretary of commerce, sponsored a bill that stated services such as "lighting, installations, and aid in the development of improvement were to be provided by the government, but land purchasing, establishment and operations of such a facility were municipal responsibilities." (Courtesy of the University of Washington.)

With the administration of Franklin Delano Roosevelt (pictured) and the resultant New Deal, the first glimpse of federal money for airports materialized. It came in the form of the Federal Emergency Relief Act (FERA) of 1933. The primary focus of this program was to create jobs for hundreds of thousands of unemployed people. During the winter of 1933–1934, 70,000 men worked at 700 different locations constructing and/or improving airports. (Courtesy of the University of Washington.)

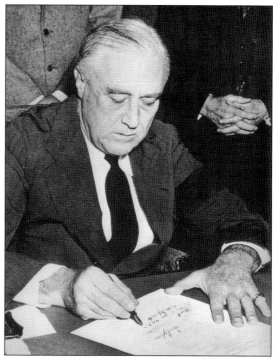

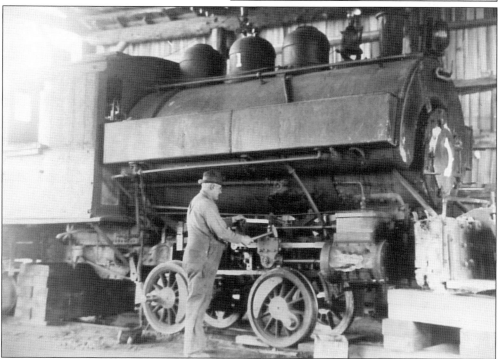

In the midst of the hardships imposed by the Depression, some local folks had reason to be grateful. The Snohomish County Airport developed due to a desire by county commissioners to construct a first-class airport for the county and to provide jobs. It would prove to be Snohomish County's largest WPA project. (Courtesy of the Everett Public Library.)

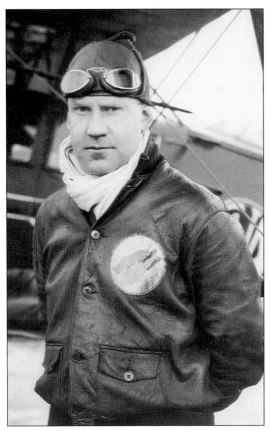

The notion of building an airport in Snohomish County was introduced prior to 1936, when flight instructor and pioneer Northwest aviator Elliott Merrill (1901–1992) was flying George Pope Sr., the owner of Pope & Talbot/ Puget Mill Company, over Paine Field. Pope pointed the area out to Merrill (pictured here) as the plane flew overhead. Merrill knew the area to be relatively fog-free. He encouraged Pope to submit paperwork to the government for construction of an airport on the parcel owned by his company. (Courtesy of the Museum of History and Industry.)

Commissioners deemed the construction of an airport "useful and beneficial to Snohomish County, Washington, and conducive to the public welfare and convenience of its inhabitants . . . and thus help relieve the unemployment situation . . . by creating a Public Works Project that will qualify under the WPA for federal aid." (Courtesy of the University of Washington.)

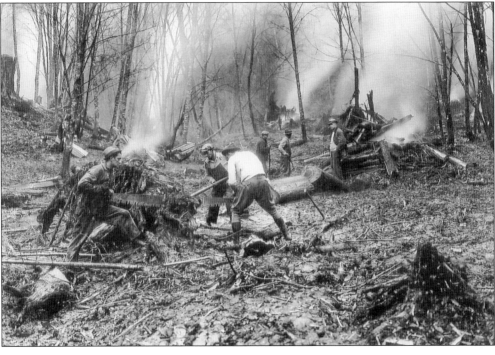

In July 1935, the Federal Emergency Relief Administration (FERA) construction projects were transferred to the WPA. From 1935 to 1938, its involvement in airport projects was impressive. Washington State was also quite involved in the program. In 1936, the WPA launched 33 projects involving airports. These projects involved clearing land, drainage, and paving. (Courtesy of the University of Washington.)

Construction of the Snohomish County Airport was performed by two steam shovels, a 20-ton locomotive with 16 cars, and 260 WPA workers, who moved from 2,500 to 3,000 yards of earth a day. The federal investment was $461,000. Snohomish County, sponsor of the project, contributed $81,000. (Courtesy of the Everett Public Library.)

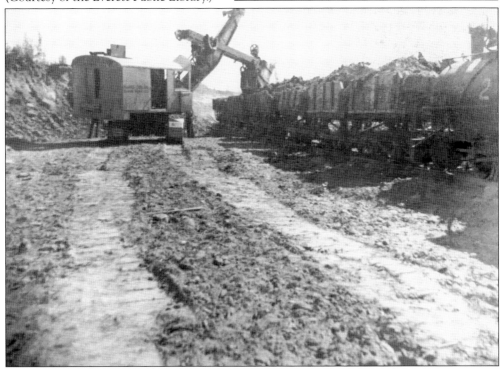

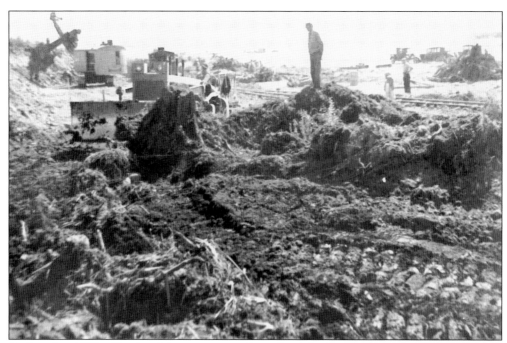

By October 1935, officials of the aeronautics branch of the Department of Commerce chose 160 acres located six miles south of Everett for the airport. The price tag for federal funding was $200,000. The *Everett Herald* provided free publicity for the naming of the proposed "super airport." (Courtesy of the Everett Public Library.)

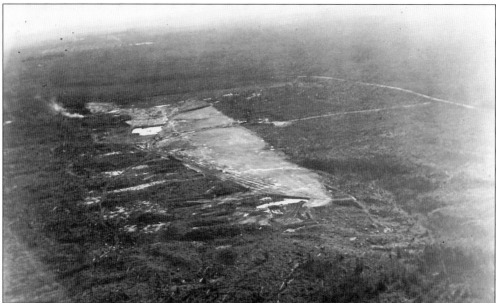

American military defense engineers chose the site because of its north–south wind and its freedom from fog, telephone poles, high-tension wires, and other hazards. It was also only 30 minutes from Seattle by automobile. Work began on September 10, 1936, with the $240,000 appropriated by the WPA for the project and the initial clearing of 115 acres. This photograph shows Paine Field around 1938. (Courtesy of the Snohomish County Airport.)

Paine Field was a relative latecomer as a WPA project. Though initial construction began in 1936, final approval for a county airport on the site did not occur until 1938. It was WPA involvement in Washington State that provided the needed support for an airport at Paine Field. (Courtesy of the Everett Public Library.)

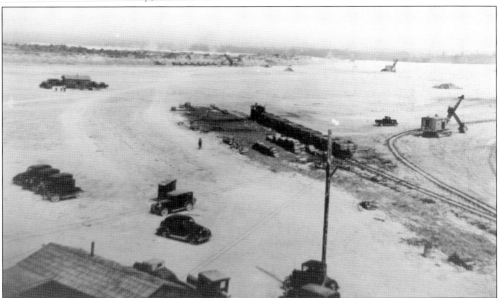

Paine Field was one of 10 airports planned by the Department of Commerce in 1935. The department was allocating $18 million for a five-year "super airport" project. Optimism at the local level ran high. According to T.H. Bowden, assistant state WPA administrator, WPA approval at the state level was being pursued. Consequently, county officials were perplexed when they found out their airport was not included on the list of approved projects in Washington, DC. (Courtesy of the Everett Public Library.)

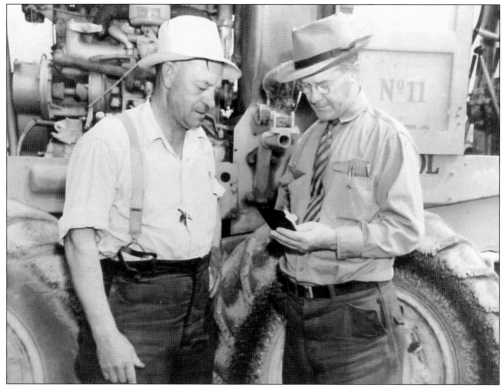

Frank Ashe, county commission chairman, made several trips to the nation's capitol, lobbying to secure Snohomish County as an airport site. During the summer of 1936, approval was granted. Ashe's efforts were rewarded with final confirmation of the airport's selection. Next, the necessary land had to be purchased. At the time, it resided in the hands of the Puget Mill Company. The corporation gave the county an opportunity to purchase 640 acres for $35,200. It was quickly accepted. Shown here is construction superintendent W.D. Hewitt (right) with a fellow construction worker. (Courtesy of the Everett Public Library.)

Following discussions between county and federal officials, the location of the airport was approved in 1936. Initial construction began immediately. Survey crews set stakes around an area that airmen had identified as fog-free. The site required intensive leveling and grading before runways could be laid, due to massive stumps, hilly terrain, and second-growth timber left behind by Pope & Talbot, a San Francisco–based logging company. (Courtesy of the Everett Public Library.)

"Construction work will start on Snohomish County's airport tomorrow. The county commissioners have purchased 640 acres of land west of the main Everett-Seattle highway, six and one-half miles south of Everett. Work will consist of clearing 115 acres, grubbing 40 acres, grading and leveling 103 acres, with excavation of 676,455 cubic yards of earth and 12,000 feet of surface ditching," reported the *Everett Daily Herald*. (Courtesy of the Everett Public Library.)

The US Army had their eye on the airport, should there be a national emergency or war. The real estate to be purchased was described as desirable for "landing, terminals, housing, airplanes and seaplanes for aerial transportation of persons, property and mail, as well as the national defense of this nation." (Courtesy of the Snohomish County Airport.)

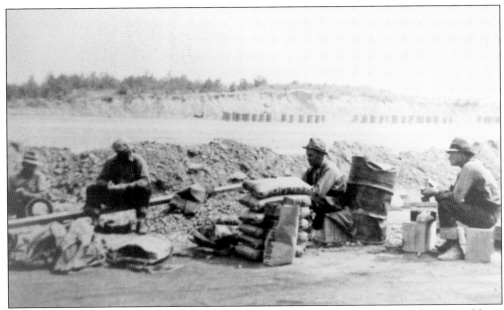

The reality of developing a commercial airport in Snohomish County appeared conceivable in early 1939. Several sources of local revenue were available, and both Pres. Franklin Roosevelt and the WPA approved the property. With the development of commercial aircraft and an increase in national transportation, a "super airport" was within sight. (Courtesy of the Everett Public Library.)

The construction of runways presented challenges for the 350–450 workers. The burning of stumps, grading, and setting of pipes for sewage and drainage were long, arduous tasks. By late 1936, initial runways were established. The longest semi-paved runway was the north–south strip, at 5,700 feet. The other three runways were shorter and narrower. (Courtesy of the Everett Public Library.)

On Sunday evening, December 27, 1936, at approximately 8:45 p.m., 10-year-old Charles F. Mattson (shown here) was kidnapped from his Tacoma, Washington, home at gunpoint by a masked man. Dr. William W. Mattson (1885–1968), the boy's father, was a well-known physician/surgeon and had played on the University of Washington football team. The kidnapper left a ransom note demanding $28,000 for the boy's safe return, then fled into the night with Charles. (Courtesy of Christopher Summit.)

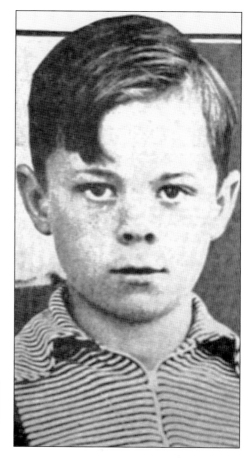

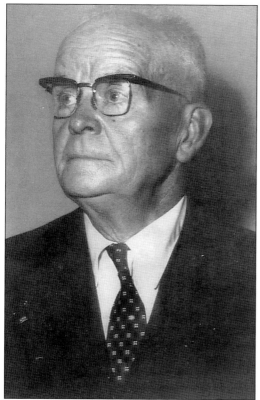

Dr. Mattson (pictured here) made every attempt to contact the kidnapper and pay the ransom money. One attempt, published using fictitious names in the *Seattle Times* personals column, read as follows: "We have received your communications. Police have not intercepted them. Channels are entirely clear. Your instructions will be followed. We are ready." Unfortunately, Mattson was unable to connect with the kidnapper. (Courtesy of Christopher Summit.)

A young man named Gordon Morrow (shown here) found the boy's bludgeoned body at Paine Field while hunting rabbits on January 11, 1937. The site, then referred to as a "Snohomish County field, approximately four-and-a-half miles south of Everett," was near Beverly Park Road, now called Holly Drive. Because the Morrow residence did not have a telephone, Gordon had to hike to Westerberg's Gas Station, 112th Street Southwest, to report the incident. (Courtesy of Christopher Summit.)

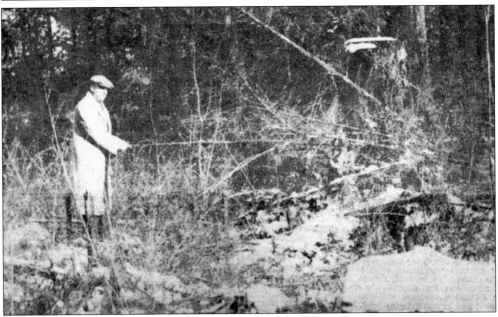

Law-enforcement officers, including J. Edgar Hoover, made every attempt to solve the murder of Charles Mattson. The only clue left behind by Mattson's killer was his footprints on the snowy ground. To this day, the case remains open by the Federal Bureau of Investigation. Charles Mattson is buried at the Tacoma Mausoleum. Here, Sheriff Walter Faulkner points to where Mattson's body was dropped at Paine Field on January 12, 1937. (Courtesy of Christopher Summit.)

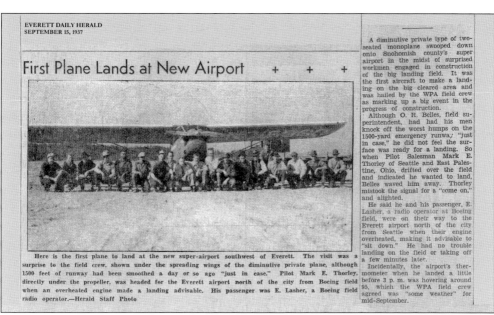

EVERETT DAILY HERALD
SEPTEMBER 15, 1937

First Plane Lands at New Airport + + +

A diminutive private type of two-seated monoplane swooped down onto Snohomish county's super airport in the midst of surprised workmen engaged in construction of the big landing field. It was the first aircraft to make a landing on the big cleared area and was hailed by the WPA field crew as marking up a big event in the progress of construction.

Although O. R. Belles, field superintendent, had had his men knock off the worst humps on the 1500-yard emergency runway "just in case," he did not feel the surface was ready for a landing. So when Pilot Salesman Mark E. Thorley of Seattle and East Palestine, Ohio, drifted over the field and indicated he wanted to land, Belles waved him away. Thorley mistook the signal for a "come on," and alighted.

He said he and his passenger, E. Lasher, a radio operator at Boeing field, were on their way to the Everett airport north of the city from Seattle when their engine overheated, making it advisable to "sit down." He had no trouble landing on the field or taking off a few minutes later.

Incidentally, the airport's thermometer when he landed a little before 3 p. m. was hovering around 95, which the WPA field crew agreed was "some weather" for mid-September.

Here is the first plane to land at the new super-airport southwest of Everett. The visit was a surprise to the field crew, shown under the spreading wings of the diminutive private plane, although 1500 feet of runway had been smoothed a day or so ago "just in case." Pilot Mark E. Thorley, directly under the propeller, was headed for the Everett airport north of the city from Boeing field when an overheated engine made a landing advisable. His passenger was E. Lasher, a Boeing field radio operator.—Herald Staff Photo

This photograph depicts the first plane to land at the new airport south of Everett. The private plane's "unofficial" landing was a surprise to the field crew on construction duty. The pilot, Mark E. Thorley, was headed from Seattle's Boeing Field to the airport just north of Everett, when he was forced to land due to an overheated engine. Luckily, 1,500 feet of runway had been smoothed a few days prior to the emergency landing. The incident was reported in the *Everett Daily Herald* on September 15, 1937. (Courtesy of the Everett Public Library.)

The Division of Airways and Airports program focused on runway facilities as well as administrative buildings, hangars, lights, and airway radio facilities. Between 1933 and 1938, federal programs accounted for 76.7 percent of airport funding. Prior to 1933, the federal government provided 0.7 percent of the funding for airports. Had the WPA not embraced aviation, air traffic in the United States would have been nearly nonexistent. (Courtesy of the Everett Public Library.)

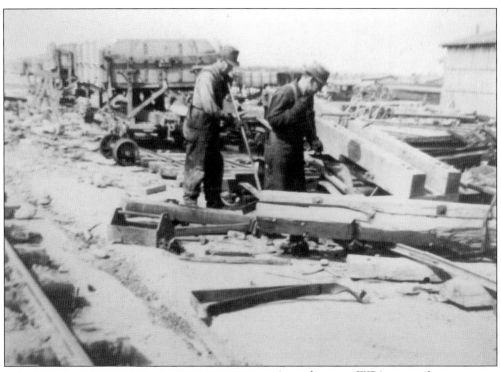

According to a WPA press release on April 10, 1939, "Snohomish County Airport supplies are now arriving on the site in large quantities. . . . WPA engineers at the Snohomish County Airport declare it is the freest airfield on Puget Sound. Large transport passenger planes have already made use of the field. . . . It is reported from Washington that the Snohomish County Airport will be used as an auxiliary airbase for the Army's war birds." (Courtesy of the Everett Public Library.)

A May 1, 1939, WPA press release stated the following: "The first of four runways to be built by WPA in the development of the 680 acre Snohomish County Airport, near Everett, is now in the final stages of construction. . . . Two courtesy round trip flights were made through arrangements by W.C. Ables, operations manager of United Airlines, for Don G. Abel, state Works Progress Administrator, Snohomish County Commissioners, newspapermen and Everett civic and business leaders." (Courtesy of the Snohomish County Airport.)

The Snohomish County Airport was designated by the Civil Aeronautics Authority as an alternate-day landing field for Boeing Field, Seattle, when weather conditions were not favorable. Both United Airlines and Northwest Airlines used it as an alternate-landing field. (Courtesy of the Everett Public Library.)

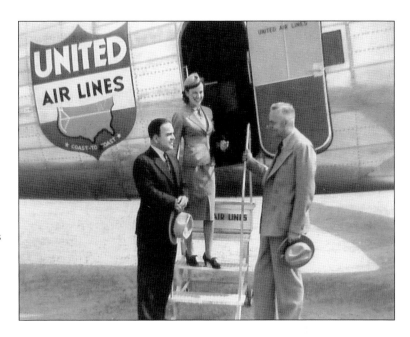

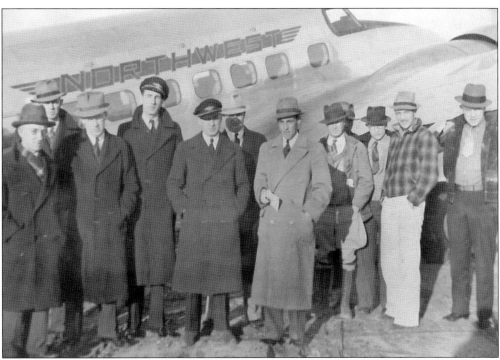

Neil Anderson describes this scene as follows: "This photograph was taken in the late 1930s or early 1940s. The gentleman standing on the left side of this photograph with his hands in his pocket and wearing a hat is Roland Hartley, Washington's governor from 1925 to 1933. The individual with his hand on the wing is Roland's grandson, David Hartley, a World War II B-26 pilot in Europe. Roland's cousin had just flown this plane from Minnesota to Paine Field." (Courtesy of the Everett Public Library.)

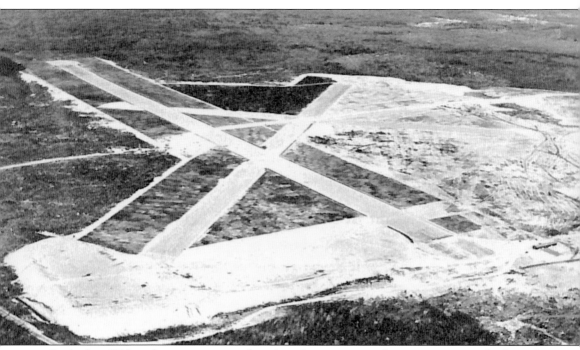

By the late 1930s, it became apparent that plans for a commercial aviation center at Snohomish County Airport would be put on hold. Over the next several decades, many factors altered the original plans for a "super airport." The first deviation from course was brought about by the entry of the United States into World War II. (Courtesy of the Everett Public Library.)

Two

WORLD WAR II

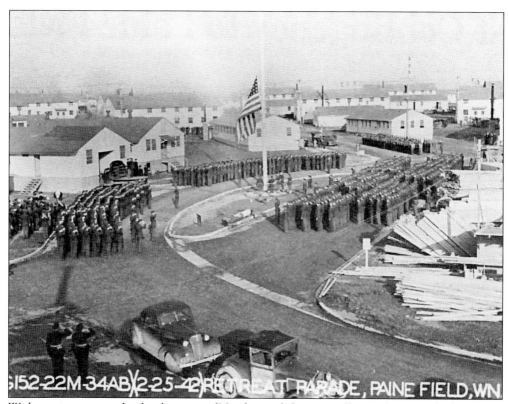

With war imminent, the development of Northwest defense installations became a high priority. Several airports in Washington were militarized for the purpose of coastal defense, war production, and training. Snohomish County's "super airport" was put on hold. (Courtesy of the Snohomish County Museum of History.)

The WPA constructed airports throughout Western Washington during World War II. With great increases in US Army and Navy planes and antiaircraft guns, the aim was for the state to be an almost impregnable defense against aeronautical invasion. Airport construction stretched from Bellingham to Mount Vernon, Everett, Sand Point, Boeing Field, Fort Lewis, and Vancouver. Other airports were built in Bremerton, Grays Harbor, and Port Angeles. A similar chain extended across the Cascade Mountains to Yakima. (Courtesy of the Snohomish County Museum of History.)

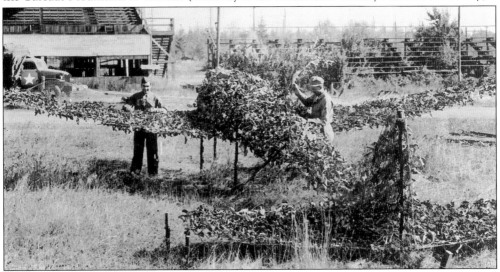

The US Army Air Corps had its own interests in developing the county airport. In September 1940, the county and the federal government signed a lease agreement allowing for military use of portions of Snohomish County Airport. The Army received exclusive "government-use only" rights to 58.8 acres in the southern section of the airport. (Courtesy of the Snohomish County Museum of History.)

The federal government felt it was important to provide air defense to Seattle's Boeing plant and airport and to the Bremerton Shipyards. The B-17 and B-29 bombers were made in Seattle. The Snohomish County Airport was selected as one of the refueling bases for these aircraft. (Courtesy of Mukilteo Historical Society.)

While the Air Corps was stationed at the airport, the county relinquished commercial facilities to the military for housing of personnel and installations, as well as the control tower. Civilian training schools were discontinued, but scheduled commercial aircraft were allowed to utilize airport facilities. The rental agreement was signed on December 21, 1940, at a cost of $1 per year. This continued until August 1941, when civilian flights at Paine Field were suspended and assigned to other airports. Commercial operations ceased. For the next four years, the airport handled mostly military operations. (Courtesy of the Everett Public Library.)

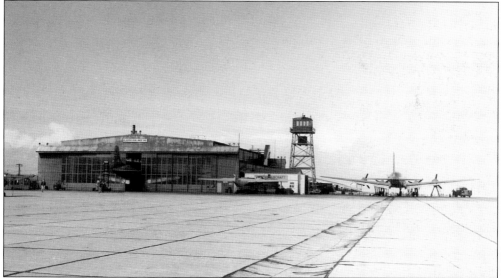

During the summer of 1941, the airport was declared a "military reservation." It was entirely deeded for the Army Air Corps repair depot. The agreement stipulated that the property would be deeded back to the county for the same $1 fee when the secretary of war determined that the property was no longer needed for military purposes. (Courtesy of the Snohomish County Museum of History.)

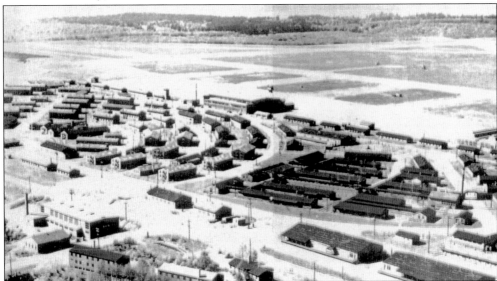

Following the Japanese attack on Pearl Harbor on December 7, 1941, Paine Field was transformed into an Army airbase. Runways were extended, housing for officers and enlisted men were constructed, and structures were erected for the care of planes. When the project was completed, approximately $2.5 million had been spent. This photograph of the first hangar under construction was taken in 1942. (Courtesy of the Snohomish County Museum of History.)

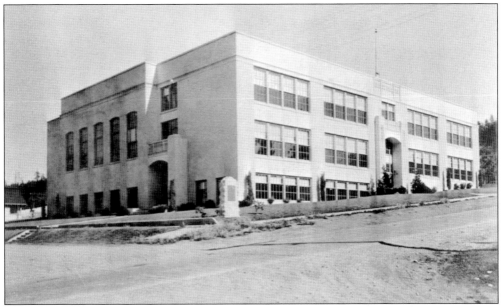

A notice from the Mukilteo Improvement Club read as follows: "There will be an important meeting tonight at the Rosehill School auditorium to organize Mukilteo and the surrounding area into an Air Raid Precaution Zone. It is vital that you personally attend this meeting so that you may understand what to do when any air raid emergency exists. . . . This community needs to be organized immediately in order to protect ourselves. We are next to an airbase, which exposes our community more than most areas. Remember the meeting is at 8:00 p.m. tonight, December 8th, 1941, at the Rosehill School." The photograph shows Rosehill School. Otto Zahler was the club's president. (Courtesy of the Mukilteo Historical Society.)

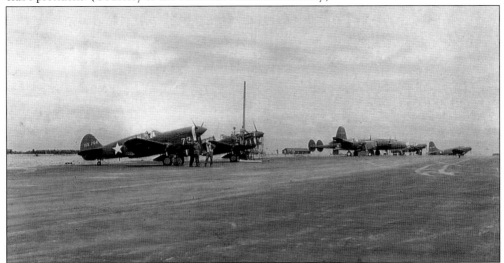

Paine Field's primary purpose during World War II was to provide air defense for the Pacific Northwest as an interceptor base for fighter planes, mostly P-38s, P-39s, and P-40s. The airport, which was significantly expanded during the war, also served as a training base for pilots and their crews prior to overseas assignments. This photograph of a P-40 was taken at Paine Field on June 11, 1942. In the background are a P-38, B-26 and B-23. (Courtesy of the Snohomish County Airport.)

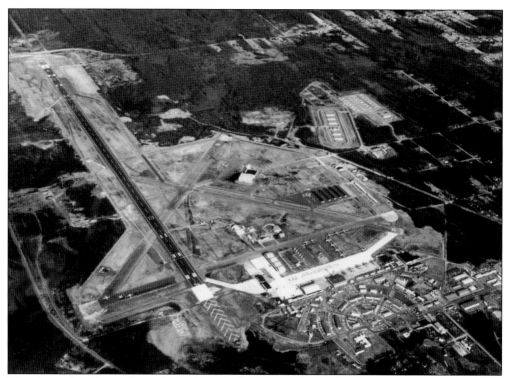

The Army Air Corps planned to arrive in the spring of 1941; however, the Civil Aeronautics Administration deemed the airport lacking as a national defense installation. The CAA asked for federal funds to improve public facilities. WPA labor and machinery were used to extend runways. An Army Corps barracks, administrative facilities, an airport tower, and a mess hall were also built. The typical "cross-section" pattern of paved runways, as seen here, allowed pilots to take off or land at the airport from different directions depending on wind conditions. (Courtesy of the Everett Public Library.)

Due to wartime tensions, civilian planes west of the Cascade Mountains were ordered to be disassembled. Local planes were stored in Cecil Crayton's former Smith & Asberry Hardware store in Marysville (shown here). Following the war, Crayton insisted that the plane owners owed him rent for storing their aircraft. Instead, many owners simply left their disassembled planes at the former hardware store. (Courtesy of the Marysville Historical Society.)

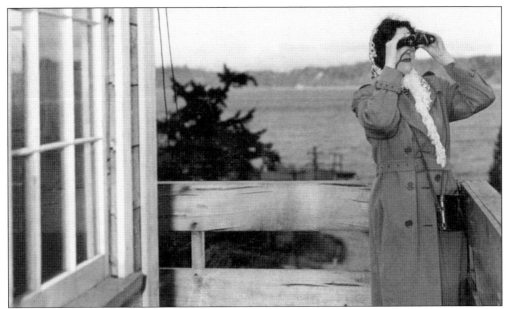

A great deal of fear spread throughout the United States following Japan's attack on Pearl Harbor. Women were encouraged to attend Aircraft Identification Schools to learn how to spot aircraft. Within two weeks, citizens of Mukilteo constructed two observation towers. The first was located near the reservoir at Park and Seventh Streets. The second was built on the bluff near Fourth Street and Mukilteo Speedway. Operated 24 hours a day, the towers were primarily maintained by women from Mukilteo through the Aircraft Warning Service. According to Dorothy Kasch, the code used when calling in from the towers was "Dog-Zero-Nine." (Courtesy of Christopher Summit.)

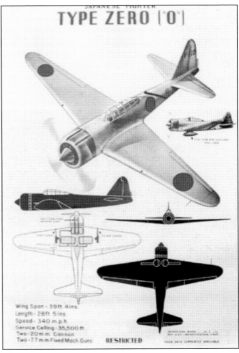

Glee Riches Shaver recalled the observation towers. "My mother and I went to the observation post at 4th Street. There were pictures of planes in the tower that we used to help identify what we saw. Of course, we all knew the P-38s. There were lots of them at Paine Field." The Aircraft Warning Service's 4th Fighter Command, which operated out of Mukilteo, included Air Observers such as Edward Hartley, George Losvar, Charlie White, Ruth Klemp, Kate LaBeau, Alice Whitcomb, and Mabel Nairn. (Courtesy of Christopher Summit.)

The citizens of Mukilteo did their part to support the war effort by making personal sacrifices, including rationing food, fuel, and tires, salvaging materials such as metals and grease, growing victory gardens, entering new occupations, and, most important, sending sons and daughters into military service at home and abroad. Here, Stella and Ernest Fischer stand in their Mukilteo victory garden. (Courtesy of the Mukilteo Historical Society.)

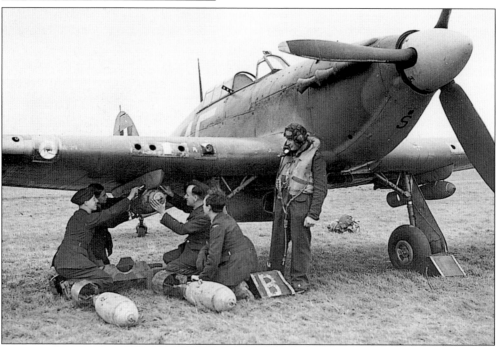

According to the *Everett Daily Herald*, "Sitting on a powder keg, the same being the transshipment area for ammunition from inland points to the Pacific Theater of Operations, Mukilteo citizens could watch from their hillside homes and see tons and tons of explosives being loaded at the huge pier built by the government in 1942. The installation at Mukilteo, which was operated in conjunction with the Tulalip Backup Ammunition Storage Depot, cost $1,349,835." Explosives might be affixed to aircraft like this British Hawker Hurricane, which is on display at the Flying Heritage Collection. (Courtesy of Cory Graff.)

The 54th Fighter Squadron, which brought P-38 and P-40 planes to Snohomish County Airport, was one of the first units to utilize the newly improved airport. With 18 military reservations operating in the State of Washington, Paine Field served as a training and defense facility. Prior to piloting P-38s and P-40s, trainees were taught the basics of flying at Paine Field. (Courtesy of the Snohomish County Airport.)

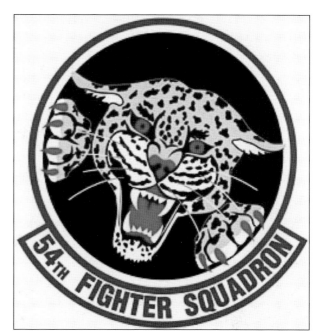

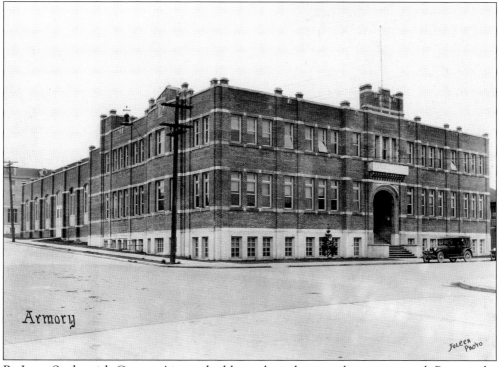

By June, Snohomish County Airport had barracks to house military personnel. Prior to the construction of the barracks at the south end of the airport, the Air Corps squadron was temporarily housed at the National Guard Armory in Everett (shown here). The building is located at California Street between Rockefeller Avenue and Oakes Avenue. "The 1921 building was designed by Lewis Svartz and resembled a castle," said Everett historian David Dilgard. The Armory was renovated in 1963. (Courtesy of Everett Public Library.)

That July, the Snohomish County Airport was renamed Paine Field in honor of hometown hero Topliff Olin Paine, an Army Air Corps pilot during World War I. Paine, an Everett boy, was erroneously reported as being killed while flying a mail route near Salt Lake City in 1922. He is buried in Everett's Evergreen Cemetery. He was born in Oswell, Ohio, in 1893 and moved to Everett in 1903 with his family. He graduated from Everett High School in 1911 and attended the University of Washington from 1912 to 1914, where he majored in civil engineering. Paine enlisted with the Army's 12th Infantry Regiment in 1917. He received his commission as a second lieutenant in May 1918 and was discharged from the Army Air Corps in 1919. Following World War I, Paine became a pilot with the experimental Air Mail Service. He had many narrow escapes from death while flying for the service and received nationwide recognition for his feats. Prior to his death, Paine was considered one of the top fliers for the Western Division of the Air Mail Service. (Courtesy of the Everett Public Library.)

On May 5, 1922, the *Everett News* reported that Topliff O. "Top" Paine died from a bullet wound received the previous Saturday night, in Salt Lake City, Utah. During the celebration of Topliff's birthday at his home with family and friends, a police officer stopped by the house to respond to a noise complaint. Hearing the knock, and having recently been robbed, Paine retrieved his revolver before opening the door. After the officer left, Olin said to his brother-in-law, W.L. Marshall, "Well, Bill, I'd better take you home." He picked up the revolver, and a shot was accidentally fired. The bullet passed through Paine's chin and exited the back of his skull. He was rushed to the hospital, but died during the operation. Neither Olin's wife, Lockie Paine, nor Marshall knew how the gun went off, as they were not looking in Topliff's direction when it was fired. Topliff Olin Paine was 29 years old. He is buried in Everett's Evergreen Cemetery. On October 18, 2003, Lorelii E. Paine, a great niece of Topliff Olin Paine, wrote to David Waggoner, airport director, confirming this story. (Author's collection.)

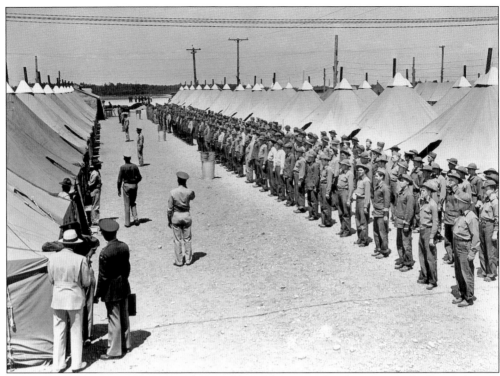

The 34th Pursuit Group from Hamilton Field, California, under the command of Lt. Col. A.C. Strickland, arrived at Snohomish County Airport in the spring of 1941. It was through Strickland's efforts that a tent city was erected after union difficulties held up barracks construction at Paine Field. Strickland worked to alleviate problems at the new post arising from an increase of new recruits and a shortage of food and housing materials. Until facilities were available, Strickland worked closely with Everett residents and businesses to provide servicemen opportunities for relaxation and entertainment. (Courtesy of the Everett Public Library.)

Photographs of pin-up girls—actresses, glamour models, and fashion models—were often "pinned up" on the walls in military housing during World War II. The term "pin-up girl," though documented as far back as the 1890s, entered common English usage in 1941. Paine Field's weekly newspaper, the *Ace Pursuiter*, featured its own sex symbols, including Carol Stewart (pictured), Virginia Mayo, and Lauren Bacall. (Courtesy of the Everett Public Library.)

This photograph was taken at Paine Field Airport in 1941. It shows Semer B. Tift, Snohomish County's last surviving Civil War veteran, in the cockpit of a Curtiss P-40 Warhawk. Originally from Blandinsville, Illinois, Tift served in Company H, 2nd Illinois Cavalry. He was mustered into Union military service on February 16, 1864. Tift died in 1944 at the age of 102. (Courtesy of the Snohomish County Museum of History.)

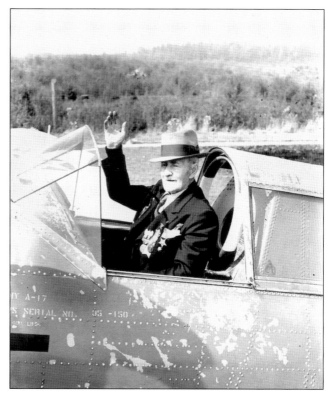

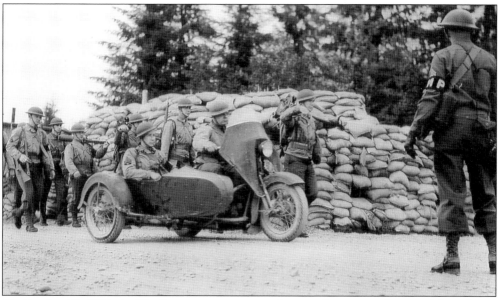

On October 22, 1941, the War Department saw a need to greatly increase the size of the military base at Paine Field. In a memorandum to the secretary of war, Henry L. Stimson, it proposed the following: "A military necessity exists for the acquisition by purchase or condemnation of approximately 160 acres of land adjacent to Paine Field . . . for Ordnance Storage Facilities. . . . Funds in the amount of $10,000.00 available from Public 13, Item 22, Ordnance Storage, Air Corps, are authorized for this project." (Courtesy of the Snohomish County Museum of History.)

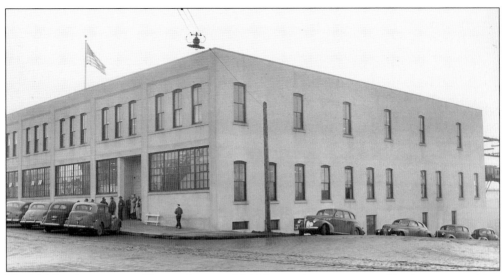

The Tulalip Ammunition Terminal accrued 2,130 acres for a storage and backup ammunition facility. Various buildings, like Everett's Boeing Subassembly Plant (shown here), located at the intersection of Hoyt Avenue and Hewitt Avenue, were also used to support the war effort. The plant building today is home to Home Inspirations. (Courtesy of the Everett Public Library.)

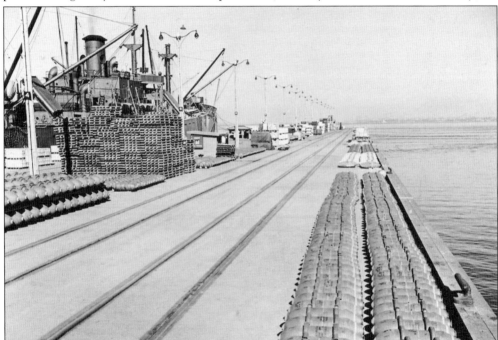

The federal government constructed the dock at Mukilteo during World War II. It was used by the Army Air Corps throughout the war as an ammunition disposal center. From this dock, ships carried shells and bombs to the Pacific. Railroad tracks ran the full length of the dock, connecting with the Great Northern's mail line in Mukilteo. Included with the dock were 18 acres of shore facilities. According to some accounts, Mukilteo was the second-largest ammunition-loading operation in the country. Bombs continue to be discovered by local skin divers. (Courtesy of the Museum of History and Industry.)

At a time when new homes cost $3,000, the idea of receiving a daily $50 in hazardous-duty pay was an incentive for local workers. Most men did not earn $30 a week. To assist military personnel, guards, mechanics, longshoremen, and other workers were hired. Greyhound buses shuttled the workers to and from the dock around the clock. Because the job was hazardous, there were numerous safety regulations. For instance, men were searched for matches before being allowed on the dock. Several close calls occurred on the dock. (Courtesy of the Everett Public Library.)

"I'm gettin' so I can sleep any damn place!"

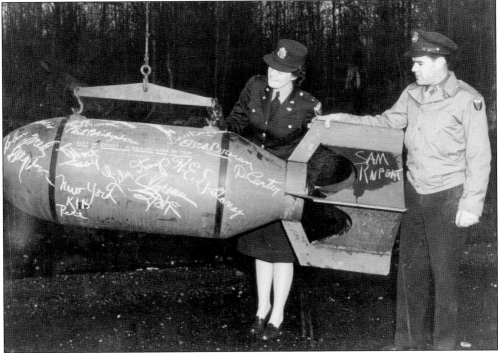

Mukilteo's John Moberg worked as a mechanic in charge of the materiel-handling equipment. He recalls, "A steady stream of train cars came and left at all hours of the day and night, carrying all forms of ammo, bombs (like the one pictured above), shells, and even poison gas and block nitroglycerine down from Paine Field. There was one person killed when, while unloading poison gas canisters, one burst. His name was Mr. Schultz." (Courtesy of the Snohomish County Museum of History.)

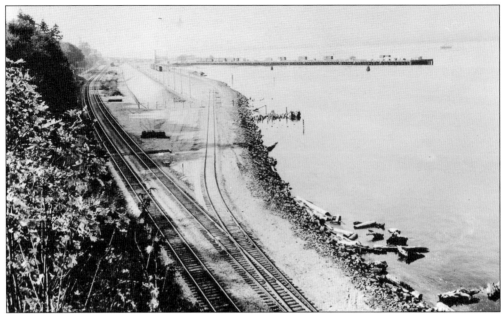

Frank H. Johnson was a Mukilteo longshoreman during World War II. He relates the following: "The reason I think Mukilteo was chosen by the government to handle munitions was because it was away from population centers, had a deep-water harbor, and easy access to the Pacific Ocean. However, it must have been stressful for the people of Mukilteo knowing they were sitting on a 'powder keg.'" (Courtesy of the Museum of History and Industry.)

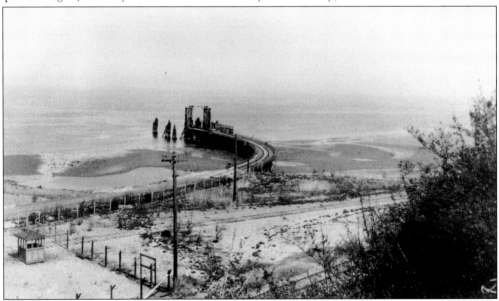

According to Virginia (Zahler) White, "I don't know where all the ships came from that loaded ammunition at Mukilteo. The ones that attracted the most attention were the Russian ships. The reason they attracted so much attention was the crew members went for walks around Mukilteo. There were men and women. They dressed in winter clothing. On their strolls, they would pick flowers. These were flowers in people's yards. They found the flowers beautiful. Consequently, no yard escaped being stripped of their flowers." (Courtesy of the Mukilteo Historical Society.)

The forced relocation of Americans of Japanese ancestry was a dark moment in American justice. However, Mukilteo was not directly impacted, because the Japanese Americans (around 300 people in the 1920s) had moved away to find work elsewhere when Crown Lumber Company closed in 1930. Many of Mukilteo's former residents were forcibly moved to internment camps. Some, like Mas Odoi (1921–2013), who was born in Mukilteo's Japanese Gulch, fought with great distinction in Europe with the famous Japanese American 442nd Regiment. (Courtesy of the Mukilteo Historical Society.)

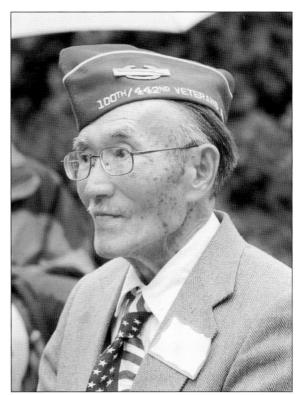

By 1942, four different WPA projects were going on at Snohomish County Airport. The federal government had pumped $2,597,005 into the projects, while the county expenditures reached $378,175. The military would provide a modern water system, access roads, and paved runways. Frank Ashe, commenting on the arrival of the Army Air Corps, remarked, "This would have been the number one airport in the Northwest, if it had not been for the government taking it over." (Courtesy of the Everett Public Library.)

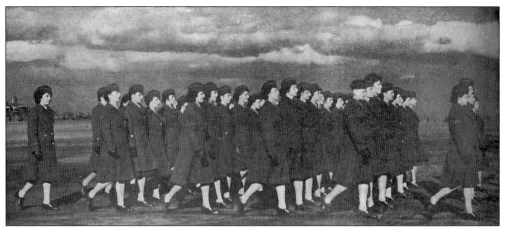

The Women's Army Corps (WAC) was created on May 15, 1942. Originally an auxiliary unit, the corps was converted to full status in 1943. Basic training took place at Fort Des Moines, Iowa. Besides nurses, WACs were the first women to serve with the Army, doing so both stateside and abroad. Though many men opposed women in uniform, Gen. Douglas MacArthur called WACs "my best soldiers." He found that they exhibited discipline, worked hard, and seldom complained. During World War II, about 150,000 American women served as WACs. (Courtesy of the Everett Public Library.)

With growth at Paine Field, more positions were made available to women. WACs and civilians held numerous positions, including the following: truck drivers, mechanics, projectionists, control tower instructors, air inspectors, historians, nurses' aids, clerks, secretaries, classification specialists, and post office and administrative specialists. Besides serving on the home front, WACs also served in various overseas units, including in New Guinea, France, India, and England. Alaska Airlines took over this original World War II Army hangar and eventually relocated near the airport office. (Courtesy of the Everett Public Library.)

While stationed at Paine Field, soldiers often conducted drills that simulated actual combat situations, including gas attacks. During these drills, soldiers wore gas masks, carried rifles, and wore steel helmets. Smoke grenades were ignited to replicate a gas attack. In the event of an actual gas attack, officials wanted soldiers trained and ready. (Courtesy of the Snohomish County Museum of History.)

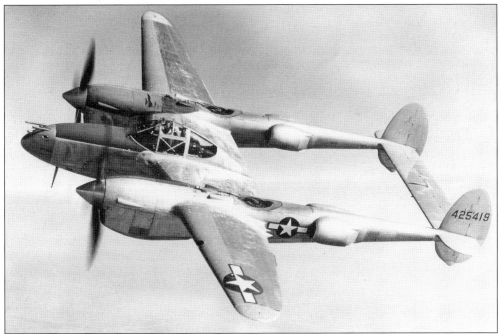

On Sunday, March 22, 1942, a P-38 airplane from Paine Field (like the plane pictured above) crashed some 600 yards off Naketa Beach in Possession Strait. A young boy named Max Whitcomb Jr. saw the plane, piloted by Robert W. Neel, go down in the choppy waters. Without hesitation, he and his younger brother, Paul, carried their 12-foot rowboat to the shoreline. Max rowed out and pulled the injured pilot aboard. Because Neel had reported his distress by radio, by the time Max rowed the pilot to shore, military personnel were waiting to offer first aid. (Courtesy of the Everett Public Library.)

```
                        Air Base Headquarters
                        Office of Commander
                        Paine Field, Everett, Wash.
                        March 23rd, 1942

Mr. Max Whitcomb Jr.
Naketa Beach
Everett, Wash.

My Dear Max:

I wish personally to thank you for your actions in rescuing one
of my pilots yesterday when he fell into the Sound in a P-38
airplane.  When it was reported to me that you, in a rowboat,
had rowed to the scene of the accident in very rough water and
had rescued the pilot, a great feeling of pride overwhelmed me.

Young men like you are the soul of our country.  When we realize
that behind our armed forces there are youngsters like yourself
who are ready to face odds in order to do your part, we know
that we need have no fear for the future.

The things that you did yesterday, Max, was much more than
rescue a pilot.  You have flashed a light for all youngsters to
follow.  You are an example to the men in our armed forces.
Your action yesterday is comparable to the actions of the boys
fighting on the Bataan Peninsula.  In other words, you saw your
duty and did it.

I wish to thank you personally and to congratulate you.  You are
to be the guest at Paine Field this Saturday.  You will possibly
feel better and more at home if you bring a guest, so my may do
so.  I am looking forward to meeting you and having lunch with
you while you are on the field.

Again, thank you for your unselfishness.  I am

                        Very admiringly yours,

                        A.C. Strickland
                        Colonel, Air Corps
                        Commanding
```

The following is an excerpt from a letter Alice Whitcomb, Max's mother, wrote to her mother on Monday, March 23, 1942: "The pilot's life vest was torn so that it was useless to him; but he clutched the parachute which would have held him up for a while, however, officers said he couldn't have lasted much longer. He had received a severe jolt and had cuts and bruises. When the lieutenant discovered that one of his engines was on fire, he radioed the field of his distress, also telling them about where he would try to land. Before Max brought him in, two of the Military Police had arrived and they carried him into our house and administered first aid until the doctor and his attendant arrived." (Courtesy of the Mukilteo Historical Society.)

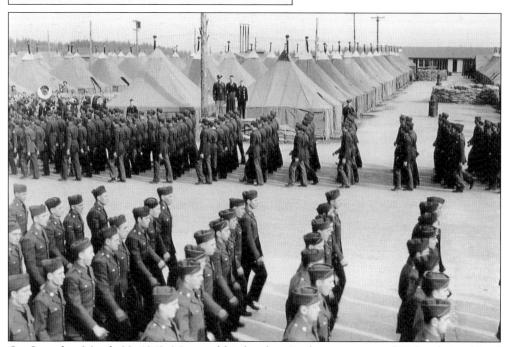

On Saturday, March 28, 1942, Max and his brother, Paul, were guests of Colonel Strickland at Paine Air Base. During their visit, they received a full review of the troops. The Whitcomb brothers can be seen near the tents, in the center of the photograph, with Colonel Strickland. (Courtesy of the Mukilteo Historical Society.).

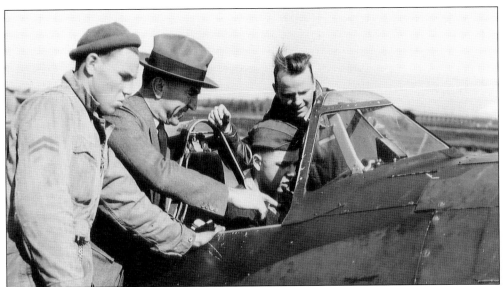

When Col. Eddie Rickenbacker came to Paine Field the next day, a meeting was arranged between Max and the legendary pilot of World War I. According to one account, Colonel Strickland presented Max with the following words: "I want an old hero to meet a new hero." Rickenbacker is shown here, second from left, in a suit, tie, and hat. (Courtesy of the Everett Public Library.)

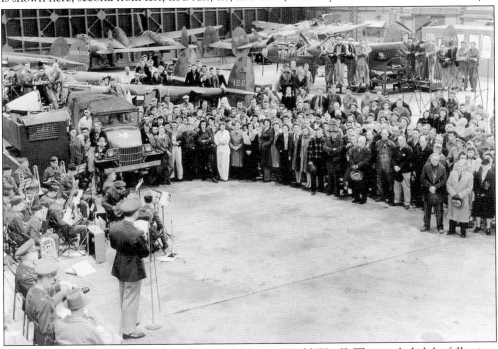

Several military units operated from Paine Field during World War II. They included the following: 54th Pursuit Group, which flew Curtiss P-40s; the 20th and 55th Fighter Groups, which flew P-38s (like those pictured here at Paine Field) and P-51s in Europe; the 33rd Fighter Group, which flew P-40s in the Mediterranean and North Africa; the 329th Fighter Group, operating P-38s; the 465th Army Air Corps Base Unit; 1021st Air Service Squadron; 24th Weather Squadron; and part of the 102nd Army Airways Communication Squadron. (Courtesy of the *Seattle Times*.)

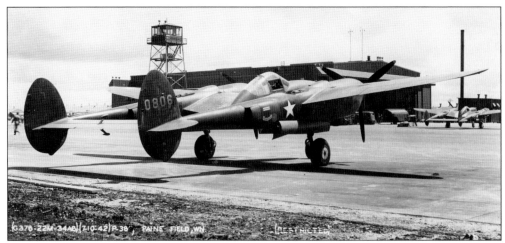

Pilots found the P-38 very reliable. The plane could reach speeds of 443 miles per hour. Designed by Lockheed in 1937, the P-38 provided allied forces with a high-altitude, twin-engine interceptor. With a length of 37 feet, 10 inches and a wingspan of 52 feet, the P-38 Lightning weighed 17,500 pounds. The single-crewmember plane reached a ceiling of 44,000 feet and had a range of 300 miles. This plane eventually crashed near Ellensburg, Washington. The pilot was killed. (Courtesy of the Everett Public Library.)

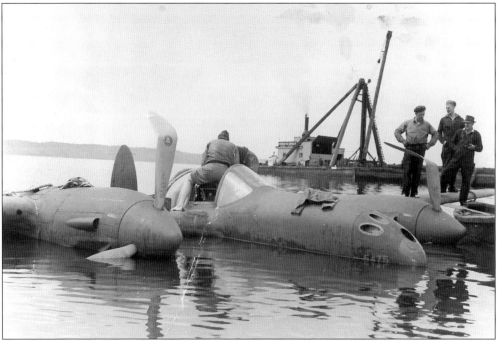

Neil Anderson relates an episode involving a P-38: "One of my mom's older sisters, Judy, attended USO socials at Paine Field and befriended several pilots. . . . The pilots would have fun flying low and doing their tricks near her house. . . . One day a P-38 climbed high into the sky, but failed to reappear. Suddenly, there was a 'thud-like' sound. Judy and her friends headed down the bluff trail to the beach. To the west, sitting in the sand and shallow water, was the missing plane. The pilot was out of the cockpit and standing on the wing looking quite upset." This crash occurred on May 2, 1942. The pilot was William K. Hester. (Courtesy of the Everett Public Library.)

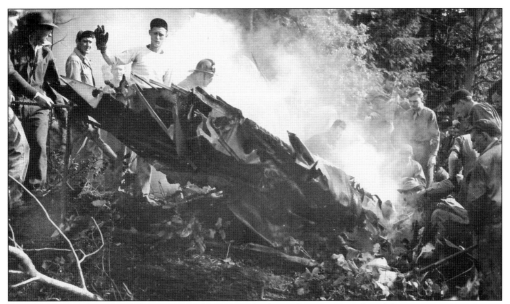

Neil Anderson describes life near an airbase: "With planes being snagged in fishing nets in Possession Sound, crashing into houses in Everett, landing on the beach at Mukilteo, and dropping from the sky near Paine Field and Silver Lake, seems like P-38s and P-40s were going down all over the place during the World War II years!" (Courtesy of the Everett Public Library.)

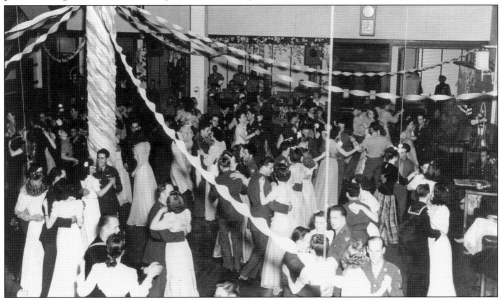

Since World War II, the United Service Organization (USO) has been providing entertainment and support to US military personnel. Founded in 1941, this nonprofit organization relies heavily upon private funding. Focusing on recreational services and troop morale, the USO has become GIs' "home away from home." Bob Hope performed for airmen stationed at California's March Field three months after the founding of the USO. Thus began a great tradition. Over the years, many celebrities have shown their patriotism by becoming USO entertainers. Shown here is a USO dance in Everett on May 1, 1943. The Everett USO was located on Wetmore Avenue between California and Hewitt. (Courtesy of the Snohomish County Museum of History.)

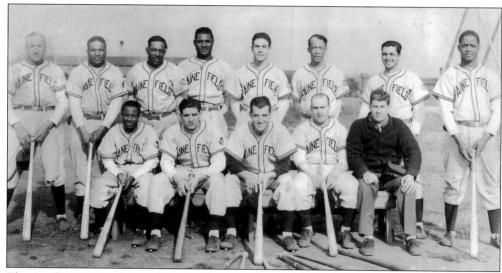

The April 22, 1944, edition of the *Ace Pursuiter* described the upcoming baseball season: "Paine Field Flyers will open their season this week with two ball games, battling the strong Seattle Fighter Wing nine tomorrow at 1400, and then meeting Fort Lawton Tuesday at 1500. Both games are scheduled for Riverdale Park in Everett (now Senator Henry M. Jackson Park). The initial appearance of the aspirants will go far in determining the starting lineup to represent the base in the Puget Sound Servicemen's League." (Courtesy of the Snohomish County Museum of History.)

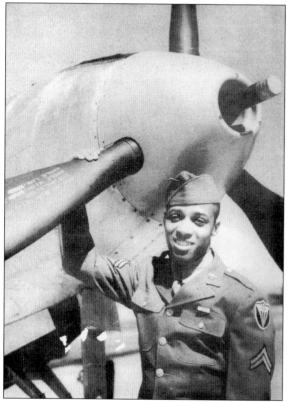

On May 6, 1944, the *Ace Pursuiter* reported, "Corporal Austin H. Ottley is the first member of Paine Field's colored personnel to be accepted for Air Cadet Training School. Corporal Ottley is a student at City College, New York, prior to his enlistment in January 1942, and is a native of the Bronx. He hopes to be assigned to Tuskegee Institute for his schooling after finishing Pre-Cadet Basic at Keesler Field, Mississippi, and in due time be commissioned as a pilot of one of Uncle Sam's fast pursuit planes." (Courtesy of the Everett Public Library.)

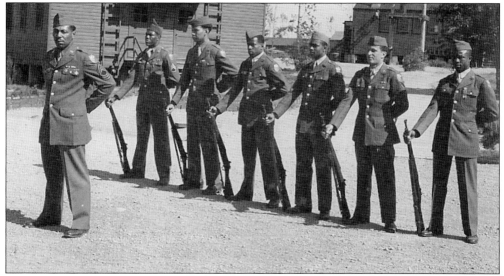

"Forward march! Hup, toop, threep, forp. And six of Paine Field's Detachment 'C' boys marched out of the Air Corps straight into the infantry. More than that, they accomplished something practically unheard of in all military history—they pestered their first sergeant and got away with it right up to the very minute they left." These words originally appeared in the June 17, 1944, edition of the *Ace Pursuiter.* (Courtesy of the Everett Public Library.)

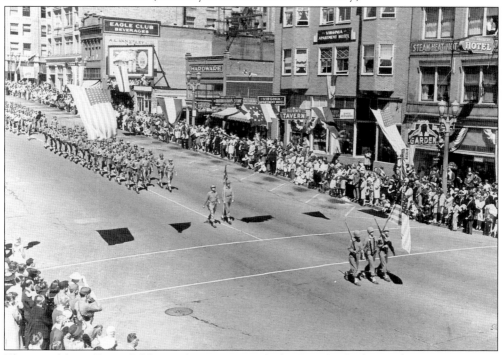

The crowd lines Everett's Hewitt Avenue to watch the Fourth of July parade in 1944. Here, a platoon of riflemen carrying M1 Garands represents Paine Field. The .30-caliber M1 was the American soldier's companion during World War II, Korea, and Vietnam. Gen. George S. Patton called it "the greatest battle implement ever devised." (Courtesy of the Snohomish County Museum of History.)

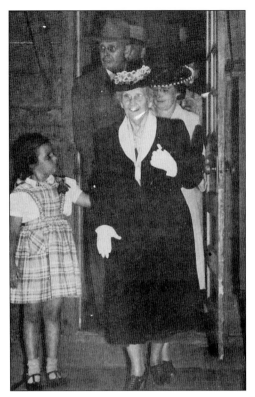

Among the visitors during an open house inspection tour of Paine Field on Tuesday, August 1, 1944, was Everett's Lucy Jane (Olin) Paine, the mother of Lt. Topliff Olin Paine, for whom Paine Field is named. She is seen here leaving the 465th Base Unit orderly room. (Courtesy of the Everett Public Library.)

Paine Field's flags flew at half-staff on Wednesday, August 23, 1944, during the funeral of 1st Lt. Charles E.R. Blair, the base operations officer. His P-39 fighter plane crashed just west of the airbase during a combat training flight. The 29-year-old flier was a well-decorated serviceman who earned ribbons from the European-African–Middle Eastern theater and the Pacific theater. Pilot error, mechanical problems, and weather conditions were often the causes of plane crashes. (Courtesy of the Everett Public Library.)

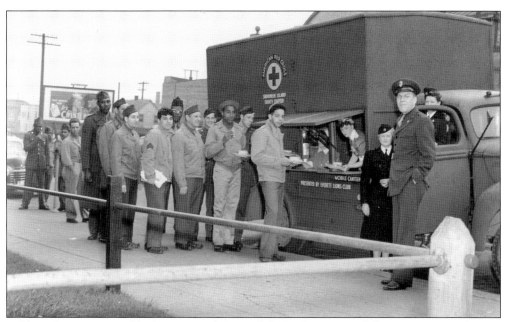

Soldiers from Paine Field often enjoyed the mobile food services of the American Red Cross Association, which was supported by donations from numerous local organizations. Dedicated to helping people throughout the United States, the American Red Cross was founded by Clara Barton and acquaintances in Washington, DC, on May 21, 1881. (Courtesy of the Snohomish County Museum of History.)

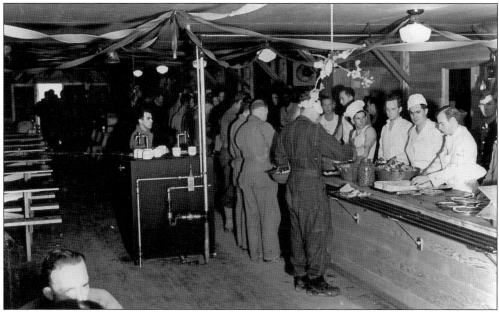

The Christmas dinner for servicemen stationed at Paine Field on December 25, 1944, proved quite a spread. The menu included celery, pickles, olives, fresh fruit salad with mayonnaise, roast turkey, sage dressing, giblet gravy, snowflake potatoes, candied sweet potatoes, green peas, corn, rolls with butter, mincemeat pie, pumpkin pie, ice cream, coffee, candy, nuts, and assorted fruit. (Courtesy of the Snohomish County Museum of History.)

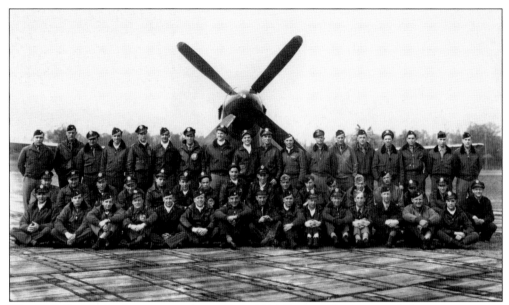

The GI Bill of Rights became a reality in June 1944. It passed by an overwhelming majority in Congress and was sent to President Roosevelt's desk. Servicemen praised provisions provided by the Special Service office. The bill contained several major provisions, including unemployment compensation, education, and financial assistance. The cost of this legislation was estimated at between $3 billion and $6.5 billion. Pictured here is the 360th Fighter Squadron. (Courtesy of the Snohomish County Museum of History.)

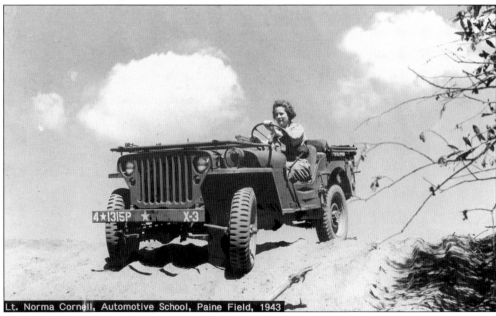

Lt. Norma Cornell, Automotive School, Paine Field, 1943

On August 4, 1944, the WACs were designated as part of the regular Army. The women moved their quarters beyond the south gate of Paine Field to the west end of the base 11 days later. Their mess hall was closed a short time later, and the women began eating with the men. Here, Norma Cornell tests a jeep from Paine Field's automotive school. (Courtesy of the Snohomish County Museum of History.)

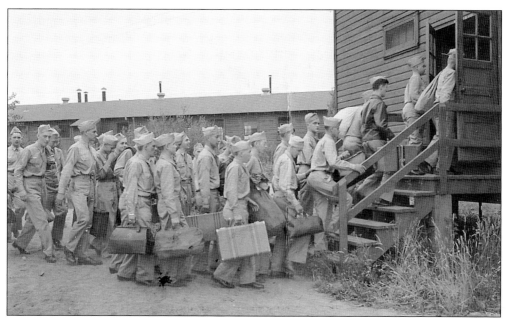

Members of the Air Corps Enlisted Reserves, mostly 17-year-olds, were invited to Paine Field in September 1944 for a close-up glimpse of the P-63 King Cobra pursuit ship, the plane most of them hoped to eventually fly. "Sure, they're just fuzzy-faced kids today, but tomorrow they'll be crack fighters, the best in the world," said Lt. Ivan A. Reitz, president of the AAF examining board in Seattle. (Courtesy of the Everett Public Library.)

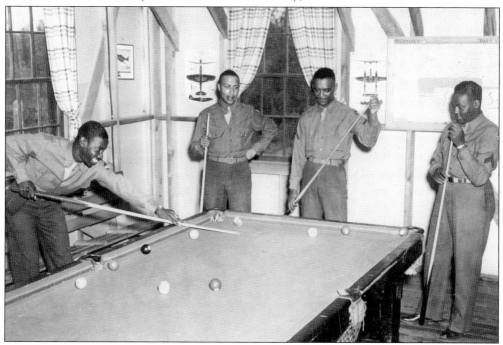

The 66th Aviation Squadron, stationed at Paine Field in 1943, was an all-black unit. Segregation was the norm at that time in the armed forces. Here, soldiers enjoy a rare moment of relaxation in the dayroom at Paine Field. (Courtesy of the Everett Public Library.)

Glenn Humann's interest in aviation started early, when he was building flying model airplanes. His first visit to the Snohomish County Airport was during a Sunday school field trip in 1939. During World War II, he joined the Civil Air Patrol Cadet program. In 1946, he acquired his private pilot certificate from Daryl Willard, of Willard Flying Service at Paine Field. Humann owned eight airplanes, which he based at Paine Field. While earning an airline transportation degree, he joined the Washington Army National Guard. After 20 years of service, he retired from the National Guard as an officer in 1968. He served three terms as president of the Paine Field Chapter of the Washington Pilots Association and is presently a docent at Paul Allen's Flying Heritage Collection. (Courtesy of Glenn Humann.)

The Civil Air Patrol (CAP) was founded prior to the bombing of Pearl Harbor in 1941. Chartered by Congress, it is the "official civilian auxiliary of the United States Air Force." The patrol provides several services to the Air Force, including emergency services (disaster relief and search and rescue), communications, aerospace education and training, and civil defense. Pictured above is a B-25 visiting the John T. Sessions Historic Flight Foundation during Vintage Aircraft Weekend. (Author's collection.)

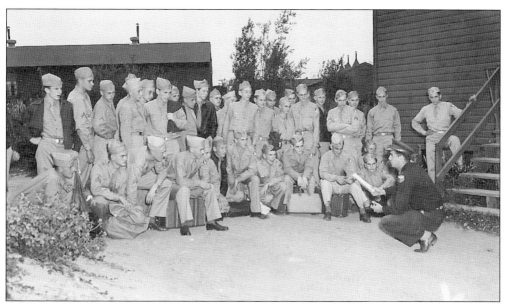

An Army Air Corps officer gives Civil Air Patrol cadets, including Glenn Humann, an orientation at Paine Field. The cadets were made up of boys, ages 14 to 17, from all over the region. Cadets gained firsthand experience involving KP duty, the dispensary, parachute loft, operations center, mess hall, and tower. Paine Field still offers the Civil Air cadet program. (Courtesy of Glenn Humann.)

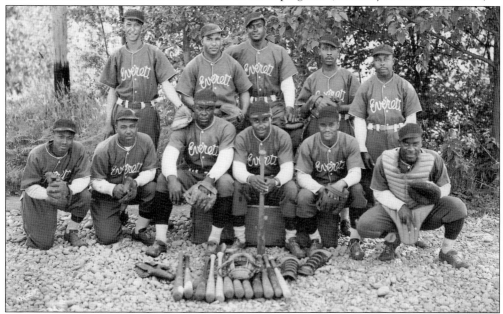

The "Brown Bombers" were formed out of the 66th Aviation Squadron at Paine Field. The team competed in the state semiprofessional tournament in 1943. Among its outstanding athletes was Beauregard, described as the most versatile player, having played every position except pitcher. Brack, the "smallest athlete on the base," was said to make up for his lack of height with speed and hustle. This information was taken from Lyle Wilson's book *Sunday Afternoons at Garfield Park: Seattle's Black Baseball Teams, 1911–1951.* (Courtesy of the Snohomish County Museum of History.)

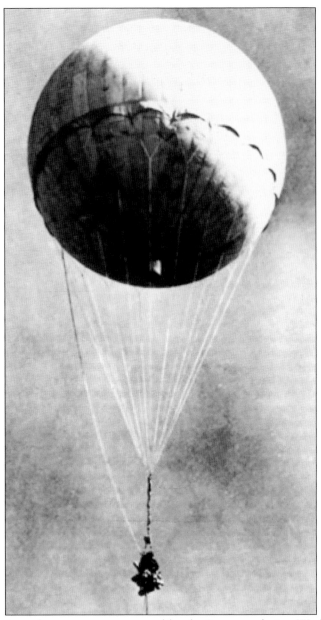

The balloon bomb, or *fugo*, was a weapon used by the Japanese during World War II. These hydrogen-filled fire balloons were outfitted with an incendiary device and weighed between 26 and 33 pounds. A relatively inexpensive weapon, the balloon bomb made use of the jet stream over the Pacific Ocean. Launched from Japan, these bomb-carrying balloons were intended to wreak havoc upon the cities, farmlands, and forests of America and Canada. Between November 1944 and April 1945, the Japanese launched 9,300 fire balloons. Relatively ineffective, only six deaths occurred (from a single incident). In the United States, 300 fire balloons were found or spotted, one of which fell near Paine Field. The balloon snagged on a tree just past the gravel pit on the road from Peck's Station to Maple Heights. Army personnel stationed at Paine Field quickly removed the balloon. Washington apparently had more "hits" from balloon bombs than any other state. (Courtesy of Christopher Summit.)

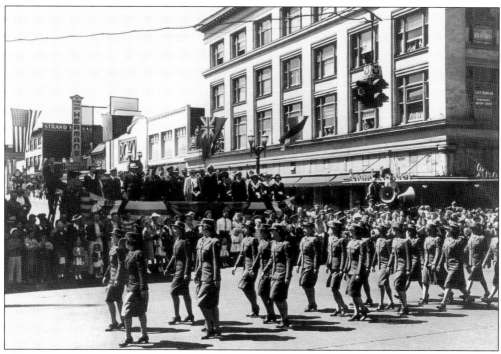

The *Ace Pursuiter* of May 14, 1945, quoted Col. Leslie P. Holcomb's address to Paine Field WACs: "Today, on this third anniversary, I believe that with three years of unquestionable service behind them, the entire army can be proud of the accomplishments of our women. Their record has proved, beyond a shadow of a doubt, that American women have been able to step into a job and do it with the highest degree of skill and satisfaction. It is, therefore, my pleasure at this time to salute the WACs of Paine Field for a job well done." (Courtesy of the Snohomish County Museum of History.)

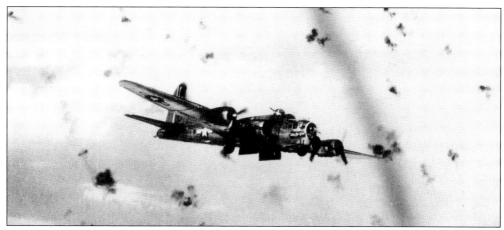

The B-17 became the symbol of America's military might during World War II. Dubbed the "Flying Fortress," the prototype made its first flight on July 28, 1935. Many of these planes were destroyed at Pearl Harbor and during battles in the Philippines. Following the war, the Forest Service used numerous B-17s as fire bombers. Approximately 20 of these planes were stored at Paine Field following the European campaign. (Courtesy of the Snohomish County Museum of History.)

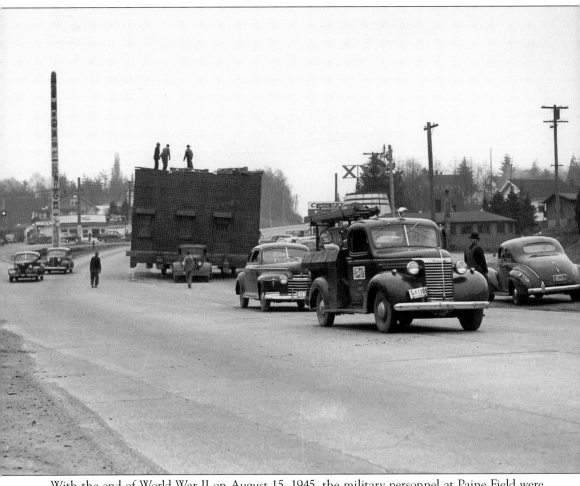

With the end of World War II on August 15, 1945, the military personnel at Paine Field were deactivated. The base became primarily a training, repair, and service facility for the Army Air Corps. The War Assets Administration began issuing county-use permits to certain buildings at Paine Field. The Everett School District, Everett Community College, and the Federal Public Housing Administration expressed interest in various installations. Here, a building makes its way down Rucker Avenue to Lincoln Field. (Courtesy of Larry O'Donnell.)

Three

EMERGENCE OF GENERAL AVIATION

The Snohomish County Airport Commission was formed in 1945. Bob Best, publisher of the *Everett Herald*, was chairman of the commission. His advisory board consisted of Dave Helms, Bob White, Ken Killien, and Don Bakken. The commission dealt with issues regarding Paine Field. After review, the advisory board passed its recommendations on to the county commissioners. Pictured above is the Historic Flight Foundation's Grumman F7F Tigercat. (Courtesy of the Historic Flight Foundation.)

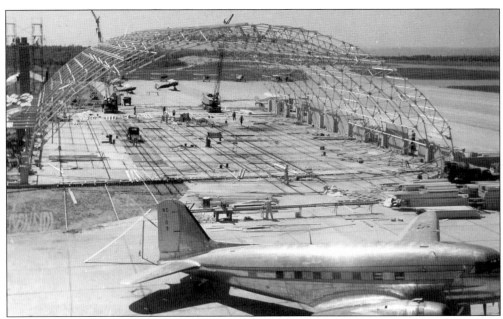

With the end of World War II, military presence at Paine Field lessened. By 1946, the military turned the keys to Paine Field over to the county, which quickly began to expand its activities. George Forbes was appointed Paine Field's first airport manager. A huge hangar (note the unique truss structure) was built to house the activities of Alaska Airlines around 1949. It is now the Flying Heritage Collection. More hangars were built for privately owned aircraft. A terminal was erected for passengers departing commercial airlines landing at Paine Field when Sea-Tac was fogged in. (Courtesy of the Everett Public Library.)

George Arthur Forbes (1916–1969) served as airport manager from 1948 to 1960. Hired to handle commercial endeavors, Forbes worked to erect a substantial terminal and civilian hangars, and he oversaw plans for expansion of businesses and air-terminal facilities. Forbes hoped profits from industry and business would pay for site improvements. He also planned to run regularly scheduled commercial flights. Revenue would also be produced from emergency landings, tie-down costs, and the rental of buildings and hangars. This would become the second deviation away from a "super airport" at Paine Field. (Courtesy of the Everett Public Library.)

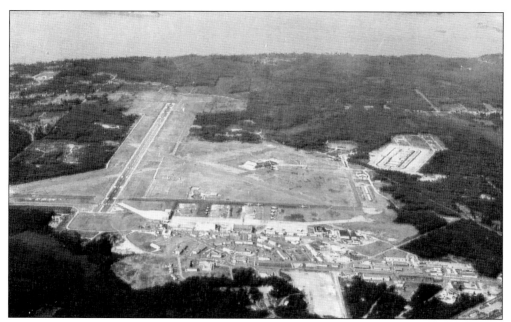

The Board of Snohomish County Commissioners contacted the US Army of Engineers on January 26, 1946, and made the following proposal: "It is hereby requested that temporary possession of the entire airport, known as Paine Field, including buildings, operating equipment, facilities and utilities be granted to Snohomish County under a temporary permit pending a final return or disposal of the entire airport." (Courtesy of the Snohomish County Airport.)

Restrictions in the deed from the federal government stated that "(1) All transferred property, buildings and equipment be used for public airport purposes and benefit of the public. (2) The airport must be maintained in good and serviceable conditions and improved under the Civil Aviation Authorities approval. (3) The property shall not be used, leased, sold . . . by the party . . . for other than airport purposes without the written consent of the CAA and (4) The transfer releases the government from liability after its evacuation." This appeared to support the original intentions of the airport. (Courtesy of the Everett Public Library.)

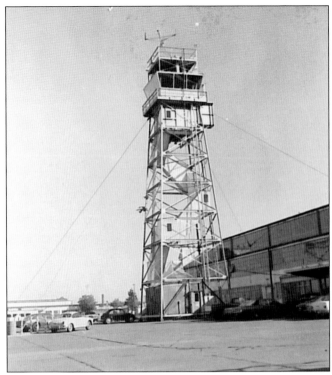

The 1946 Surplus Property Act made possible the transfer of acreage from the federal government to the county. This included easements involving roads, highways, power and utilities, sewers, and hazardous areas. Included was everything from oil and paint storage buildings to Paine Field's two-deck, original air traffic control tower (Tower No. 1). The warehouses, mess hall, and two-story barracks provided space as well. Operational areas such as taxiways, roads, runways, and aprons (which provide paved areas for parking, loading, and servicing) were given back to the county. (Courtesy of the Snohomish County Airport.)

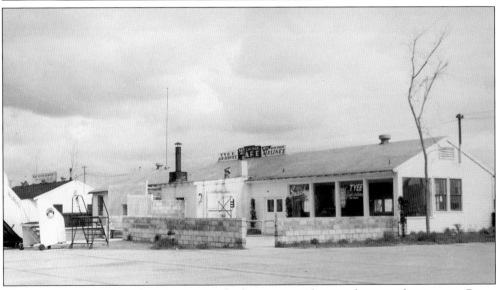

The Civil Aeronautics Administration, which represented nonmilitary authority over Paine Field, provided information regarding the 1948 "quit-claim" document. This document allowed for the expansion of civilian business and industry in buildings no longer used by the military. Both aviation and non-aviation business proved beneficial to the airport. The hope was that such business would support an eventual commercial air center, and that "such a release is necessary to protect the interests of the United States in civil aviation." Tyee Air Service would become the first aircraft service facility to take up residence in the "quit-claim" Army buildings at Paine Field. (Courtesy of the Snohomish County Airport.)

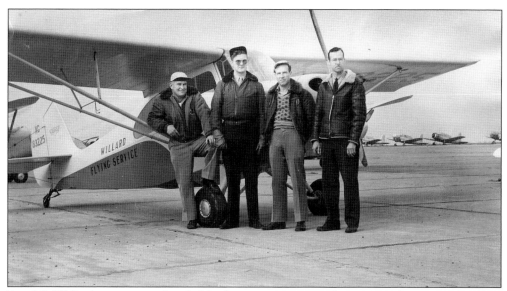

Daryl C. Willard, a pioneer in Pacific Northwest aviation, was the owner and operator of Willard Flying Service at Paine Field after the close of World War II. During Willard's 32 years in aviation, his achievements include numerous firsts. Among these are the first mail-carrier flight from this area, the first "official" aircraft landing at Paine Field, and the first flight to Orcas Island. Washington's 1946 Pilot of the Year is credited with training more pilots than any other instructor. He logged approximately 20,000 flying hours. The 1969 Paine Field Air Fair was dedicated in honor of Daryl C. Willard. Pictured from left to right are Bill Doeg, C.F. Bartschat, Fred Barron (Daryl's brother-in-law), and Daryl C. Willard. (Courtesy of the Snohomish County Airport.)

Born in 1911, Willard grew up near Coupeville on Whidbey Island. He managed the old Everett Airport from 1938 until the start of World War II. During the war, all civilian aircraft west of the Cascades were required to have their wings removed to prevent flight. Following the war, Willard established Willard Flying Service at Paine Field. He rented two former military buildings on the flight line. One was used as an office and one for maintenance. These buildings were later removed to build the original Tramco hangar. At night, Willard kept his planes in the original Army Air Corps hangar. (Courtesy of the Snohomish County Airport.)

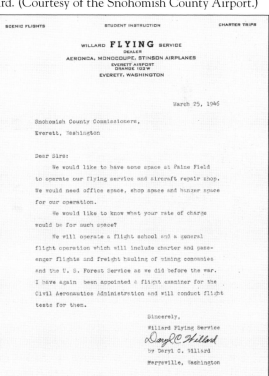

No. 338

Souvenir Flight Ticket

WILLARD FLYING SERVICE

EVERETT AIRPORT--EVERETT, WASH.

LEARN TO FLY FOR $75.00

DEALER FOR
AERONCA, MONOCOUPE & STINSON AIRPLANES

When Paine Field was reactivated, at the beginning of the Korean War, Willard's facilities were relocated to a former military building on the east side of the airport, in the present vicinity of Runway 16L-34R. At this time, two corrugated metal "T" hangars were built. Willard occupied six hangars for storage and maintenance. From dawn to dusk, he worked seven days a week, twelve months of the year, except Christmas. During the winter months, he overhauled engines and did other maintenance jobs. Daryl Willard died on June 2, 1969, in a midair collision with a Stinson 108 near the Snohomish Airport. He was 58 years old. (Courtesy of the Snohomish County Airport.)

Constructed by Patrick Guy Neff, Everett's Memorial Community Church, located at 710 Pecks Drive, was the original base chapel. It served soldiers stationed at Paine Field during World War II. Northwest Hauling Company of Tacoma moved the 95-ton building to its present site. Because of the muddy conditions and narrow roadways, the move proved a formidable task. It was not until July 1948 that the chapel was settled at its new location. The Baptist church's first pastor was Rev. Fred Fahringer. His wife's name was Edna. Since 1948, Memorial Community Church has undergone several renovations. (Author's collection.)

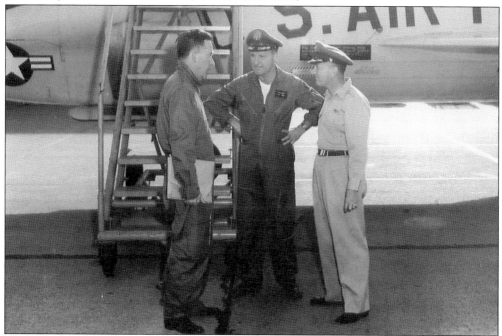

County plans to pursue a "super airport" were again halted when war threatened the United States in the late 1940s. This time, the conflict was in Korea. In 1949, Rep. Henry M. Jackson (1912–1983), pictured on the left in this photograph, toured Pacific Northwest defense installations and concluded that more military presence was needed. Consequently, on April 1, 1951, Paine Field was reactivated as a joint-use airbase. The portion of the airport used by the military was officially renamed Paine Air Force Base. The 4753rd Air Base Squadron was the principal occupant. (Courtesy of the Everett Public Library.)

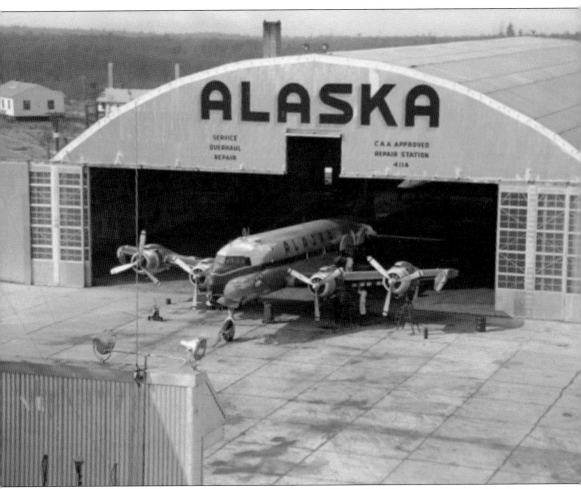

Significant changes in general aviation took place at Paine Field between 1946 and 1952. The US Army Air Corps left in 1946. New businesses included Willard Flying Service, Rust Flying Service, Tyee Flying Service, Paine Field Flight Service, Cessna Club (Snohomish Flying Service), Island Airways, Nick Bez's West Coast Airlines, Alaska Airlines Maintenance Facility, and Castle Industries. This photograph shows Snohomish County Airport's Building 207 (looking west), home of the Flying Heritage Collection. (Courtesy of the Everett Public Library.)

Four

KOREAN WAR

At the end of 1950, the future of Paine Field Airport was again in question. The Korean crisis was escalating. Pres. Harry Truman proclaimed a state of national emergency on December 11. US Air Force brigadier general Colby M. Meyers approved the acquisition of most of Paine Field. Tenants occupying needed installations had until the new year to evacuate. Commercial facilities allowed to remain in operation for CAA use, such as Alaska Airlines, Snohomish County, and Castle Industries, were restricted to flight and airport activities. This became the third reason a "super airport" was delayed. (Courtesy of the University of Washington.)

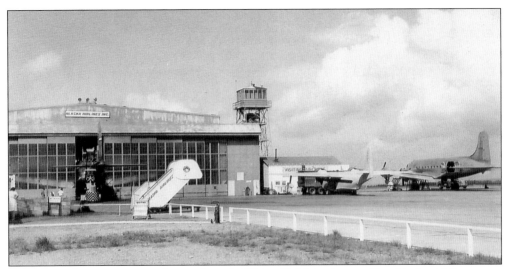

With the military occupying the south end of Paine Field, businesses like Alaska Airlines were forced to turn their hangars over to the Air Force. The hangars were used to house jet interceptors during maintenance and repair. The Alaska Airlines hangar today houses Paul Allen's Flying Heritage Collection. This is the original Army Air Corps hangar (Building 201) built during World War II at Paine Field, standing east of the Flying Heritage Collection. (Courtesy of the Snohomish County Museum of History.)

Much like the Army Air Corps occupation in the 1940s, the Air Force needed to expand its military installations and improve the existing facility. Land was acquired through condemnation, leave, and purchase. Major projects taken on by the Air Force included extending the north–south runway; expanding military facilities, such as ammunition storage for the Air Force and Aerospace Defense Command Unit; and building an Air Force Reserve Combat Training Center. (Courtesy of Bill Canavan.)

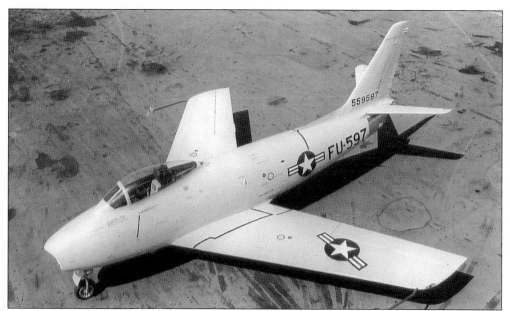

In 1951, the US Air Force Aerospace Defense Command Unit arrived at Paine Field, bringing with it supersonic jet interceptors and a substantial payroll. A vital Western Defense Command post, Paine Field served as an alert-status military base with jet interceptors and tactical radar installations. F-89C Scorpion fighters, "first-generation" jets, were housed at Paine Field. F-84 Thunderjets and F-86 Sabre fighters (shown here) also operated from Paine Air Force Base. (Courtesy of the Snohomish County Airport.)

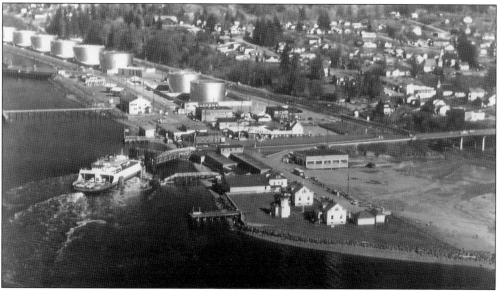

The 10 steel fuel-storage tanks located in Mukilteo were constructed by the Air Force during the Korean War. During this time, the Air Force was very active at Paine Field, both day and night. Prior to its removal on September 30, 1997, the "Tank Farm" was a local landmark. On September 10, 2013, the Port of Everett Commission accepted transfer of the Mukilteo Tank Farm from the US Air Force. After nearly 70 years, Mukilteo will once again have access to its waterfront. (Courtesy of the Mukilteo Historical Society.)

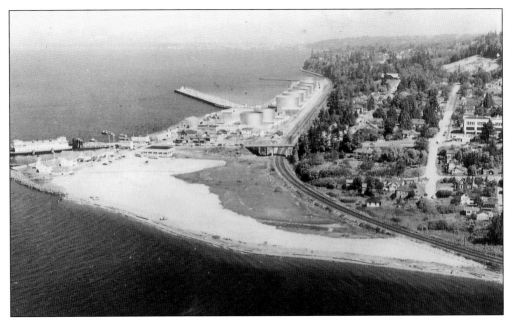

Prior to construction of the fuel-storage tanks at Mukilteo, the area was used for storing and loading ammunition. This occurred for only a brief period, as local residents opposed the dangerous operations. Perhaps they recalled the explosion that occurred near Mukilteo at the Puget Sound & Alaska Powder Company on September 17, 1930. As a result, the Air Force moved its munitions depot to Bangor, Washington. (Courtesy of the Snohomish County Airport.)

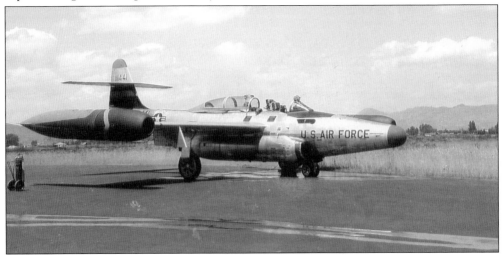

Ron Ziegler recalls his time at Paine Field: "As a newly-minted 2nd Lieutenant, I was assigned to the 83rd Fighter Interceptor Squadron at Paine Field Air Force Base on November 24, 1952. . . . The following April I was transferred; but returned in 1955 and served as the Base Adjutant from June until November 1955. . . . The F-89 [shown here] was a great aircraft. I remember being in attendance at an early briefing with the Northrup representative who warned us that the plane was not designed to break the sound barrier. But he knew we would try; so, he recommended we start at 50,000 feet and then start pulling at 40,000 feet. I ended up marrying a flight nurse. As newlyweds, we started our family here and cherish great memories from this beautiful part of the country." (Courtesy of the Snohomish County Airport.)

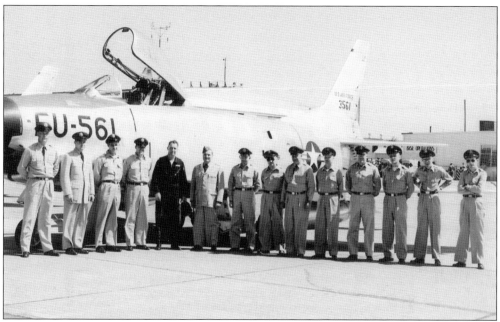

This photograph shows the 529th Air Base Squadron standing in front of an F-86 at Paine Field on July 14, 1955. Pictured from left to right are Major Rodzankas, Chaplain Dier, Major Parlavechi, Lieutenant Colonel Donalson, Colonel Wintermute, base commander Major Miller, Major Lovan, Lieutenant Colonel Grashio, Lieutenant Colonel McDowell, Major Anderson, Captain Gottholt, Captain Kier, Captain Wulff, and 1st Lt. Ron Ziegler. (Courtesy of Ron Ziegler.)

In December 1956, $50,000 in federal funds were secured to build a civilian hangar and terminal at Paine Field. Manager George Forbes hoped a county airport at Paine Field would begin to take shape. This plane belonged to Everett Junior College and was acquired through the War Assets Administration, which sold off surplus World War II assets (jeeps, planes, boots, etc.). Pictured near the propeller of this staggerwing Beechcraft 17 is Everett Junior College faculty instructor Larry Blakely. (Courtesy of the Everett Public Library.)

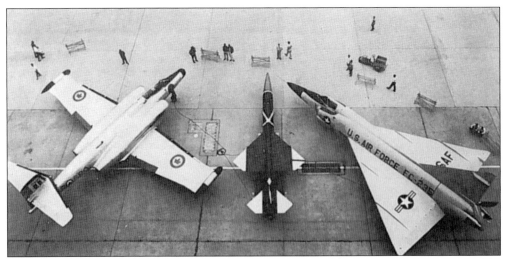

In August 1959, the federal government purchased 11 acres east of the airport for construction of the BOMARC missile site. The name "BOMARC" was short for Boeing and Michigan Aeronautical Research Center. The first BOMARC site in the Pacific Northwest was to be located at Paine Air Force Base. Sen. Henry M. Jackson and Congressman Jack Westland made the announcement in the spring of 1958. Launched vertically, the missile was equipped with a target-seeker system and carried a high-explosive warhead. This project was discontinued halfway through its production when liquid-fueled missiles became obsolete and deemed no longer necessary to the American defensive strategy. The 100-acre BOMARC Business Park is located in the northeast corner of Snohomish County Airport near Kasch Park. (Courtesy of the Snohomish County Airport.)

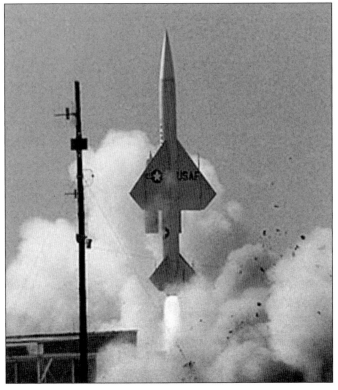

Paine Field was part of the 25th North America Defense (NORAD) region. It primarily supported the 25th Air Defense Command, stationed at Tacoma's McChord Air Force Base. The Air Defense Command (ADC) defended against manned-bomber attacks. Through a network of radar stations along the coastline, any unidentified aircraft were detected through a central computer system capable of transmitting to all ADC installations. The Joint Canadian–US Military Group was established on September 12, 1957. (Courtesy of the Everett Public Library.)

Paine Field Air Base was considered vital in the defense of the Pacific Northwest. Base commander Col. Ira F. Wintermute summed up his opinion of the airport when he said, "As part of the 25th Air Division, Paine Field is responsible for the air defense of the Seattle area and its industrial complex. . . . A look at the globe shows how strategically we are situated on the Great Circle Route." (Courtesy of the Snohomish County Airport.)

Col. Samuel C. Grashio, commander of Paine Air Force Base, was born in Spokane, Washington, in 1918. In 1940, he began flight training at Randolph-Kelly Field in Texas. By 1941, Grashio was flying P-35s and P-40s in the Philippines. He helped defend the islands until he was captured on April 9, 1942, when the Philippines were surrendered to the Japanese. Grashio spent 361 days in a prisoner-of-war camp, but escaped and was eventually evacuated by submarine to Australia. He served out the rest of the war performing various military duties at home and abroad. (Courtesy of the Snohomish County Airport.)

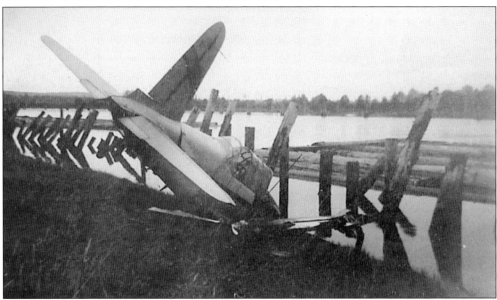

The Aircraft Accident Listing for Paine Field (1937–1955) represents aircraft accidents at the airport or near its vicinity. Some information regarding planes is still incomplete, missing, or erroneous. Records continue to be updated. The most current report shows minor and major aircraft accidents that occurred on and off the flying fields. In all, the report lists 67 accidents involving planes at Paine Field. This war surplus BT-13 crashed near the old Ebey Island Airport. (Courtesy of the Snohomish County Museum of History.)

The US Air Force and Kiwanis International sponsored Kids Day at Paine Air Force Base. It was offered annually to kids from Snohomish County and north King County. Shuttled in by school buses, the kids were treated to demonstrations, movies, tours, and Air Force "chow." Paine airmen and officers provided guided tours. Thousands of children participated in the event. (Courtesy of the Snohomish County Airport.)

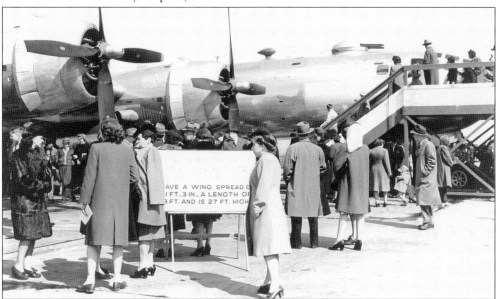

Armed Forces Day was an annual celebration at Paine Air Force Base. The program featured flyovers, various displays, and an open house. Armed Forces Day, which drew thousands of citizens from Snohomish County, was intended to show American citizens how military forces were using "power for peace." The aircraft at Paine were always the biggest draw. Every squadron at Paine participated. Armed Forces Day was held on a designated Saturday in May. (Courtesy of the Snohomish County Museum of History.)

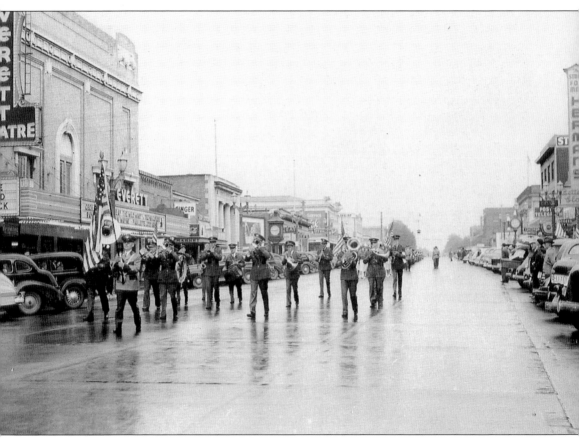

Paine's official ceremonial and marching unit was the Paine Air Force Base Honor Guard. This unit consisted of airmen from each squadron. During military ceremonies and parades, the unit performed precision movements and close-order drills. Unit commanders selected men for this unit based upon their "military bearing, appearance and service record." Though the roster consisted of 30 men, only 20 performed at a time. This consisted of four members from the color guard, fifteen men, and the honor guard commander. The base commander selected the honor guard commander, who served for six months. Here, the Paine Air Force Base Honor Guard is marching down Everett's Colby Avenue during a Fourth of July parade. (Courtesy of the Everett Public Library.)

Paine Air Force Base offered a variety of facilities, including the following: commissary, cafeteria, barbershop, education office, laundry, legal office, library, nursery, Military Affiliate Radio Service (MARS), Office of Information Services, Non-Commissioned Officers' (NCO) Club, Officers' Club, Officers' Wives' Club, Non-Commissioned Officers' Wives' Club, Airmen's Wives' Club, post office, telephone and telegraph office, theater, thrift shop, religious office, Service Club, Toastmasters Club, gymnasium, bowling alley, Aero Club, transportation office, dispensary, dental office, veterinary clinic, newspaper office (the *Cockatrice*), and post-exchange (shown here). (Courtesy of the Everett Public Library.)

"War dogs" have a long history, dating back to ancient times. The Egyptians, Greeks, Persians, Britons, and Romans used them as trackers, scouts, and sentries. Highly trained sentry dogs were utilized to keep intruders from restricted areas at Paine Air Force Base during the Air Force occupation of Snohomish County Airport. (Courtesy of the Snohomish County Airport.)

Off-base housing was available to airmen and married couples stationed at Paine Air Force Base. Everett, which was located six miles north of the base, had apartments and houses for rent. Lynnwood, Edmonds, and Mountlake Terrace, south of the base, also offered housing. Prices ranged from $25 a month for a duplex to $85 a month for a partially furnished three-bedroom home. Apartments ranged from $50 (one bedroom) to $100 (two and three bedrooms) a month. Pictured above is the Paine Air Force Base chapel during a wedding ceremony. (Courtesy of the Snohomish County Museum of History.)

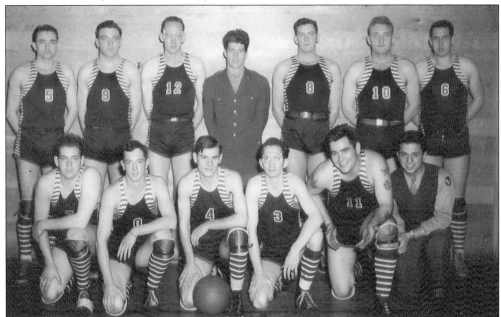

Special Services handled sports at Paine Air Force Base. The base offered intramural softball and basketball leagues. Bowling was also very popular. The bowling alley had four lanes with semiautomatic pinsetters. The Paine baseball team consistently competed for the league championship. Special Services also provided boats, boxing gloves, golf equipment, tennis racquets, skis, archery equipment, and rifles. (Courtesy of the Snohomish County Museum of History.)

The 321st Fighter Interceptor Squadron was activated on August 25, 1942. Its last assignment was with the 316th Air Division, stationed at Paine Air Force Base. The 321st provided air defense for the Northwest United States. Its pilots flew the F-89J Scorpion. The squadron was stationed at Paine Air Base from August 18, 1955, until it was discontinued on March 1, 1960. (Courtesy of the Snohomish County Airport.)

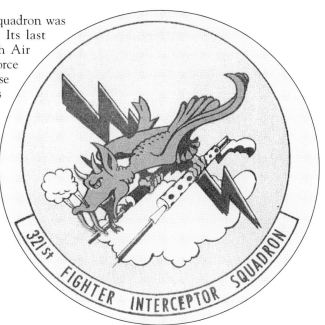

This photograph depicts typical housing provided at Paine Field Air Force Base during the 1950s and 1960s. This duplex, located on Bomarc Road, belonged to C.M.Sgt. Patrick Shea, who was based at Paine Field from 1956 to 1964. (Courtesy of the Snohomish County Airport.)

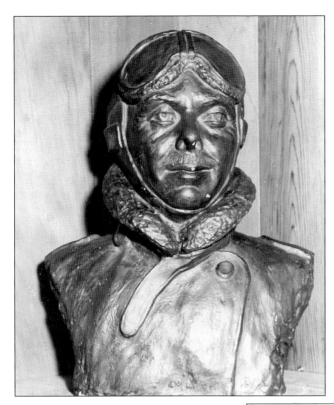

For years, a large bust of Lt. Topliff Olin Paine adorned the Officers' Club at Paine Field. Following World War II, while the Air Force was occupying the south end of the airport, the bust mysteriously disappeared. It was not uncommon for military personnel to play pranks. Servicemen were also known to collect mementos. However, to this day, the bust of Lieutenant Paine has never been returned to Paine Field. (Courtesy of the Snohomish County Museum of History.)

It was not until 1960 that the potential of the airport was realized. George Petrie, a former Naval Reserve commander and businessman-flyer, replaced the retiring George Forbes and served as airport manager from 1960 to 1966. His goal was to carry out Forbes's plans to expand the airport. A regional consulting team of engineers (Anderson, Bjornstad, and Kane) developed a comprehensive plan for Paine Field. (Courtesy of George Petrie.)

George Petrie focused on the development of the commercial half of the airport. His plan was to attract business and industry to Paine Field with short-term leases. These small businesses, or "incubator" companies, were basically leasing 4,000 square feet of office space. It was the "shared use" agreement between the Air Force and Snohomish County Airport that allowed Petrie to put into place his "expansion-minded proposals." This would become the third reason for the delay of a "super airport" at Paine Field. (Courtesy of the Everett Public Library.)

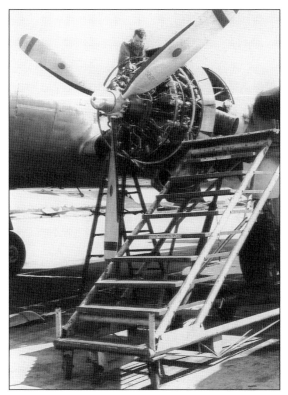

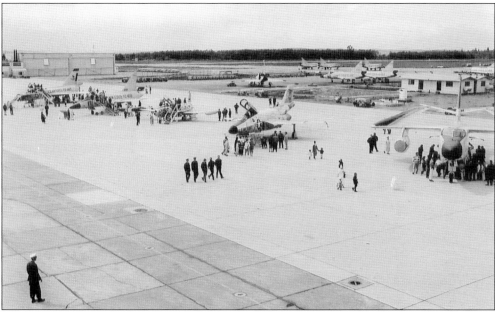

By 1966, the Highway 99 directory listed 16 tenants in the 100-acre industrial park, with other businesses operating opposite the "off limits" area that separated commercial property from the USAF. Examples of small businesses included radio repair services, lighting equipment manufacturers, camping trailers, a restaurant, as well as charter flights, flight instruction, and aircraft sales. (Courtesy of the Snohomish County Airport.)

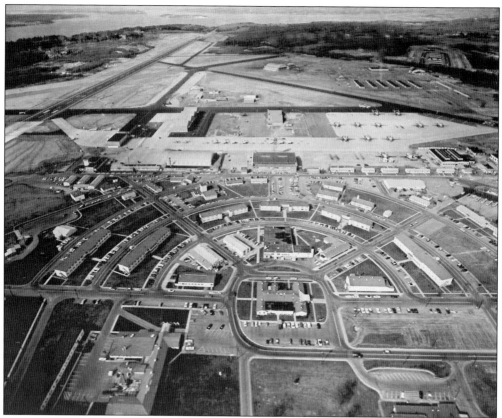

In the 1960s, Paine Field consisted of approximately 1,369 acres. The Air Force occupied 540 acres, and 590 acres were joint-occupancy. The remaining 239 acres were for civilian use. This latter portion of the airport offered renewed hope for a "super airport" in Snohomish County. (Courtesy of the Snohomish County Airport.)

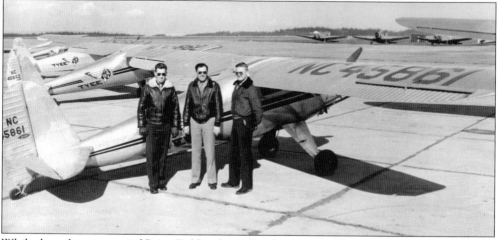

While the military occupied Paine Field, industrial and commercial businesses, along with military revenue, continued to support the local economy. Alaska Airlines, Willard's Flying Service, and Tyee Air Service all took up residence at Paine Field. Pictured here are Tyee Flying Service instructors, including Bill Crump (center). (Courtesy of the Snohomish County Airport.)

In 1966, the Air Force began closing Paine Field Air Base for budgetary reasons. The airport returned to civil control in 1968. At the time, the Washington Air National Guard remained at Paine Field, and it continued to operate a facility known as the Paine Field Air National Guard Base. The Air Guard is no longer at Paine Field. It was decommissioned effective October 1, 2013. (Courtesy of Bill Canavan.)

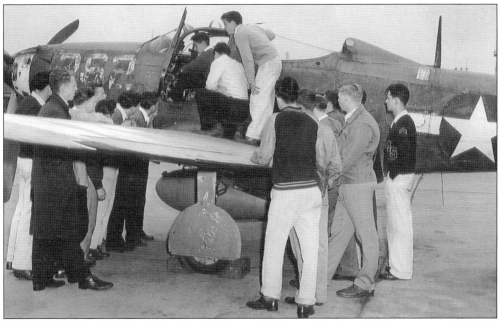

Until 1968, Paine Field continued as a "joint-use" airport. Snohomish County expanded the north portion of the field. The federal government made several improvements to the south, including a runway/taxiway system. While it was a joint-use facility (Air Force and Snohomish County), the Snohomish County Airport had a very small staff. This skeleton crew consisted of the airport manager, secretary, and two field workers. In the summer, college students were hired as temporary workers to assist with general maintenance (mowing, painting, and building repairs). Pictured above is a P-39 made by Bell Aircraft. (Courtesy of the Snohomish County Museum of History.)

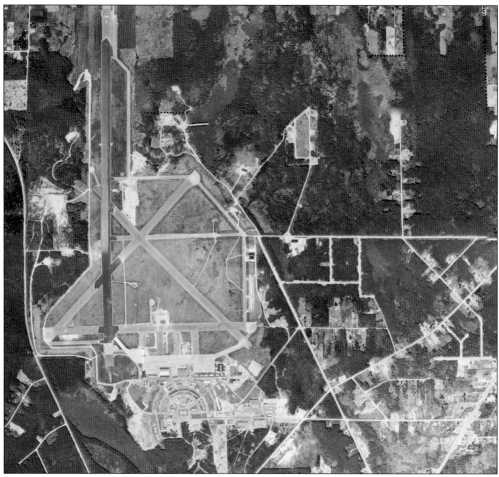

During this joint-use time, the tower at Paine Field was operated by the USAF. The airport was operated by the Snohomish County Airport Commission. Runway 16-34 (the vertical runway at left), measuring 9,000 feet by 200 feet, was primarily used by jets and large aircraft, as well as by light aircraft upon request. All night landings took place on Runway 16-34. Runway 11-29 (running diagonally from the left) had displaced threshold and measured 3,400 feet by 75 feet. It was used by light aircraft during daylight. Light aircraft were not to cross Runway 16-34 unless approved by the tower. (Courtesy of the Snohomish County Airport.)

Five

BOEING

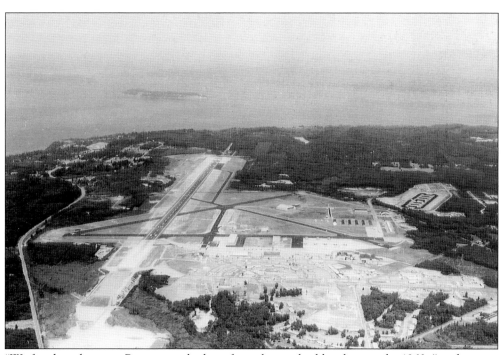

"We first heard rumors Boeing was looking for a place to build a plant in the 1960s," said airport manager George Petrie. "Bob Best, owner of the *Everett Herald*, knew Boeing's heir apparent, Bill Allen. Bob and I met with Boeing in secrecy. Best said to Allen, 'We have a proposal to option 300 acres to Boeing.'" (Courtesy of the Snohomish County Airport.)

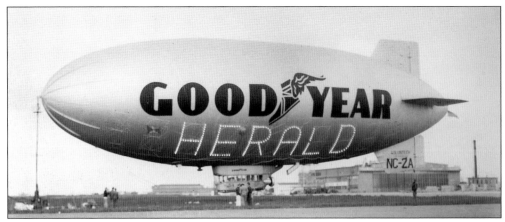

In April 1966, the *Everett Herald* ran the headline "Boeing Considering Paine Field For Site of 747 Plant." At the time, Boeing optioned over 1,200 acres of Modern Homebuilders land for possible use. The surrounding community debated such topics as how to accommodate a reported 10,000 employees and their families, a revised road system, and funding for new schools. Shown here is the Everett Herald's Good Year balloon, which frequently advertised at Paine Field. (Courtesy of the Snohomish County Airport.)

In negotiating a contract with Boeing, Snohomish County was up against many obstacles and had to consider several factors. It was negotiating a long-term contract far into the future. "This 75-year lease was compared to leaders at the end of the Civil War attempting to project what would be taking place in the 1940s," said George Petrie (left), shown here with Don Bakken. (Courtesy of George Petrie.)

"During our negotiations with Boeing, I was trying to get the best deal possible for Snohomish County" said previous airport manager George Petrie. "I found Boeing very fair to work with; so long as you were fair with them." Located to the east of Airport Road, this ground is leased to Boeing by the Snohomish County Airport. (Courtesy of the Snohomish County Airport.)

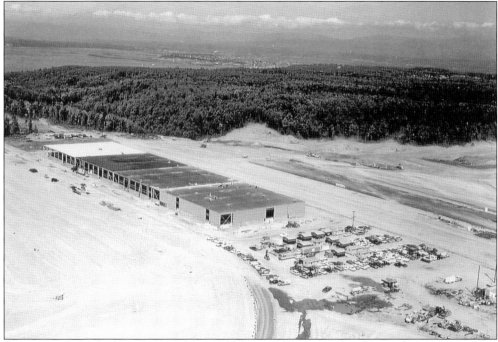

Boeing decided to build at Paine Field in 1966, but it did not immediately reveal its decision. After conducting soil samples, Boeing finally disclosed its intent. Paine Field was chosen over Cleveland, Monroe, and Moses Lake. In June, the Boeing Company purchased 780 acres northeast of Paine Field. By January 3, 1967, work began on the 747 factory. On May 1, 1967, the factory officially opened. (Courtesy of the Snohomish County Airport.)

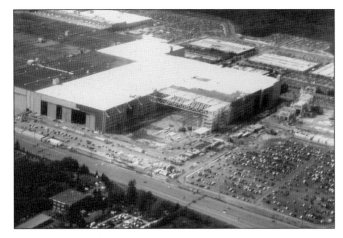

Land just north of Paine Field was selected for the Boeing plant. With the Air Force pulling out of Paine Field in 1968, the arrival of Boeing did much to support Snohomish County business interests. At this time, a proposal was made that the Paine Field Airport become the state's second regional airport. Local and FAA personnel suggested that the site offered an ideal location. (Courtesy of the Snohomish County Airport.)

When the Air Force pulled out of Paine Field, Snohomish County needed the FAA to come in and operate the control tower, which Boeing wanted in operation. However, the FAA did not have enough money. Airport manager George Petrie contacted Boeing lobbyists, who took the matter to Sen. Warren G. Magnuson (1905–1989). Magnuson (right) secured funding for the FAA. Though the Air Force had left, it still flew up from McChord Air Force Base and practiced its approaches at Paine Field. In 1969, the FAA took control of the tower. Henry M. Jackson is shown here with his arm around Magnuson. (Courtesy of the University of Washington.)

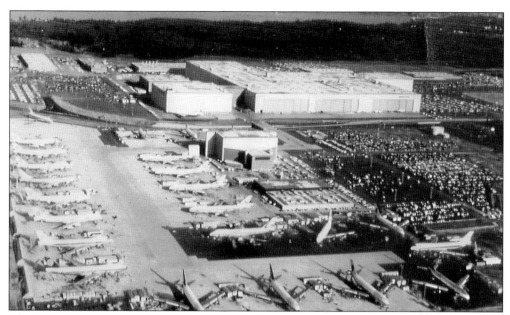

The Boeing plant went a long way toward securing Paine Field's future. With the departure of the military, Boeing alleviated monetary needs that helped cover airport upkeep, such as operation and maintenance costs. Boeing's arrival also played a key role in the growth of the local population. Community involvement led to the expansion of Paine Field as a general-aviation airport with air-carrier capabilities when the Northwest's regional airport, Sea-Tac, was fogged-in or overcrowded. This would become the fourth movement away from the original federal plan for a "super airport" at Paine Field. (Courtesy of the Snohomish County Airport.)

One reason Boeing was hesitant to choose Paine Field had to due with the steepness of Japanese Gulch. Boeing needed a railroad and planned to build a steep rail line from the Great Northern tracks in Mukilteo's Old Town to the Boeing plant. This spur would pass through Japanese Gulch, the steepness of which would prove to be quite an obstacle. However, the railroad spur was eventually completed. (Author's collection.)

On August 1, 1966, an announcement was made by the Boeing Company ratifying the Everett site as the official location of the 747 project. A railway was constructed through Japanese Gulch. This spur, which ran from Puget Sound to the Boeing plant, allowed railway cars to haul materials for the construction of what would be dubbed "the world's largest building" by volume. Today, the Boeing Everett factory is the primary assembly plant for Boeing's 747, 767, 777, and 787. It has its own control tower attached to the assembly plant. (Author's collection.)

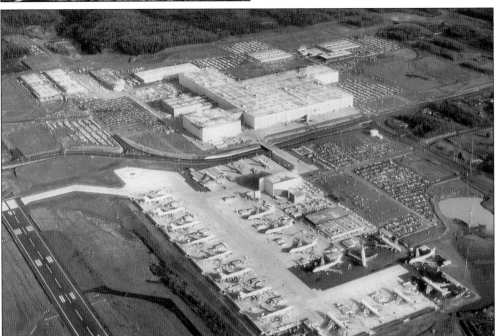

On June 15, 1966, the Boeing Company and the Snohomish County Airport Commission reached a long-term agreement. The next day, a contract was signed. Boeing was granted use of Paine Field's north–south runway, which was now 9,000 feet long, and its existing taxiways. If the Everett assembly plant decided to build airliners, the commission would extract fee payments, costs for improvements, and landing fees. Currently, Snohomish County Airport receives a landing fee for aircraft weighing over 12,500 pounds. (Courtesy of the Snohomish County Airport.)

Boeing flew its entire board of directors up to tour the new factory at Paine Field. They landed their 727 in front of airport manager George Petrie's office. Charles Lindbergh was one of the members of Boeing's board. "I watched him deplane and climb into a limo before heading to the plant," said Petrie. (Courtesy of Snohomish County Museum of History.)

In 1967, Boeing opened for business and began the assembly of 747 jumbo jets in Everett, Washington. Boeing's involvement with Everett did not begin with jetliners. During World War II, the company provided subassembly support for the B-17 from two facilities in Everett. This included a radio operator's section and work on bulkheads. (Courtesy of the Everett Public Library.)

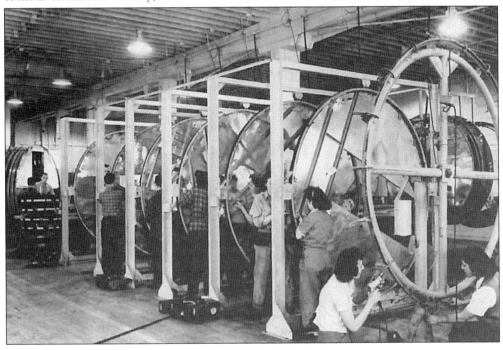

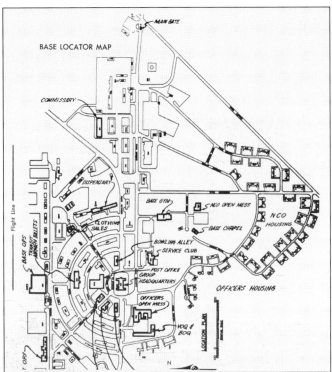

Through a quit-claim deed, the Air Force turned its joint-use facilities and military property over to Snohomish County. This meant the loss of an annual military payroll of $9.7 million. The Boeing plant would be counted on to make up the lost revenue. It was preparing for the rollout of the 747. With the Boeing boom, the expanded industrial park, and a wide-open airport, the development of a major commercial airport at Paine Field once again seemed possible. (Courtesy of the Boeing Company.)

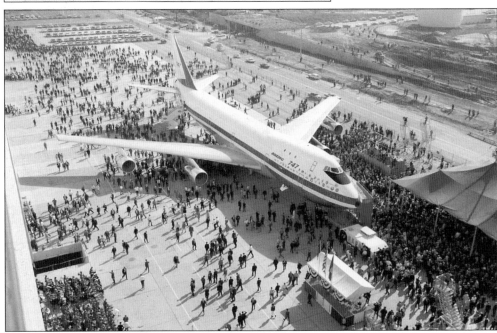

The first Boeing 747 "Jumbo Jet" rolled out of the plant in Everett, Washington, on September 30, 1968. More than twice the size of the Boeing 707, the plane was originally designed to transport passengers and cargo. In order to assemble the giant plane, Boeing constructed the world's largest building by volume (291 million cubic feet) at Everett's Paine Field. (Courtesy of the Snohomish County Airport.)

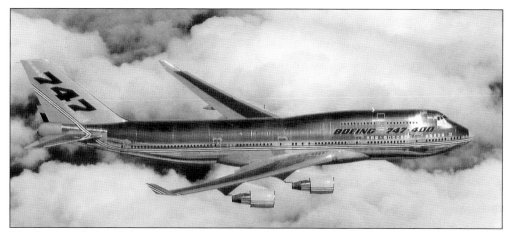

The first test flight of the Boeing 747 occurred on July 9, 1969. At first, people were concerned about the impact of a 747 on the runway. But the jet proved to have less impact than a 707 or DC-10, due to its 16 wheels. Pilot Jack Wadell trained in a simulator prior to his test flight. On the day of the test flight, the weather at the airport was marginal. There were scattered clouds, so the plane sat on the runway for 30 minutes. Finally, Wadell said, "Let's go flying!" (Courtesy of the Snohomish County Airport.)

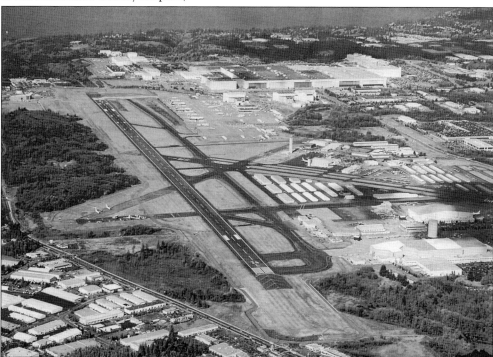

In 1967, Snohomish County once again pushed for a "super airport" at Paine Field. Growth in Puget Sound and an overcrowded Sea-Tac became selling points. Plans called for the construction of a major aviation airport that would feature 54 gate positions and central and satellite terminals. General aviation facilities would be replaced with needed service, parking, and hangar requirements. The proposal was dismissed when the FAA doubted the need for a second regional airport. Shown in this modern photograph is the location of Paine Field's third control tower. (Courtesy of the Snohomish County Airport.)

The Air Force deactivated Paine Field in 1968, and the last personnel departed in 1972. The Air Force proved a major asset for Paine Field, including performing maintenance work on runways and utilities. Some of these improvements dealt with issues dating to the 1930s. The Air Force also manned the control tower. When the Air Force deactivated, the FAA built a new control tower in 1974. (Courtesy of the Snohomish County Museum of History.)

For the first time, the FAA began operating the control tower at Paine Field in 1969. That same year, a revised comprehensive plan was completed. It consisted of two proposals. The first dealt with financing improvements for terminal expansion, a possible air-cargo center, hangars, and revised railway system and road. The railway system and road would benefit Boeing and the future growth of light industry. George Petrie (left) is pictured here standing in front of the control tower. (Courtesy of George Petrie.)

From the 1960s through the 1980s, many of the remaining military buildings to the east of Paine Field were converted to civilian businesses that made up an industrial park. The largest company was Castle Industries, a subcontractor to Boeing. Among other jobs, Castle had a contract with Boeing to build seats for military aircraft. It also constructed seats for Boeing bombers, like the B-52. This photograph shows one of the original Alaska Airlines hangars. (Courtesy of the Snohomish County Airport.)

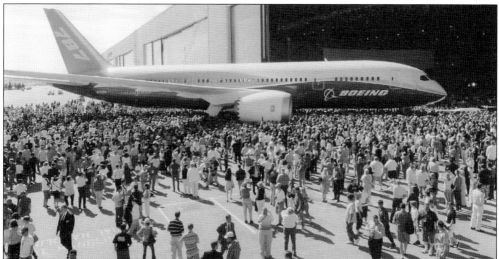

The Boeing 787 "Dreamliner" made its first flight from Paine Field on December 15, 2009. Made mostly of composite materials, the first passenger jet promised "a 20–25 percent better fuel efficiency than conventional metal jets." It was 27 months behind schedule, due to production delays and strikes by the International Association of Machinists and Aerospace Workers in 2005 and 2008. Planned for five and a half hours, the initial flight was cut back to three hours due to inclement weather. Delivery of 787s began in late 2010. On Friday, February 17, 2013, Pres. Barack Obama spoke at the Boeing plant, with three Dreamliners and a banner that read "An America Built to Last" as the backdrop. (Courtesy of the Boeing Company.)

As of July 26, 2013, Snohomish County officials were contemplating an $8-million proposal to prepare an industrial site at Paine Field for the manufacture of the Boeing Company's new 777X project. Should Boeing opt not to expand at the county airport, the site could be used by another aviation business. "Our plan is to get the permits for an industrial pad and perhaps do some of the development," said David Waggoner, director of Paine Field. (Author's collection.)

Boeing has provided economic stability for the community. With the recent closing of Kimberly-Clark, the area's reputation as a "milltown" has vanished. Fortunately, the city has been able to rely on aviation. Boeing employs more than 43,000 workers in this community, and it employs thousands of other people in aviation-related jobs. Pictured here is a portion of the world's largest digital graphic, according to Guinness World Records, applied to the front of Everett's Boeing assembly plant. The woman pictured here is Regina Burton, a German-based fashion model. (Author's collection.)

Six

AIR FAIR YEARS

Dr. Elliott G. Boisen, president of the Lynnwood Rotary Club, spoke about the club on June 29, 1969. "The Lynnwood Rotary Club was formed in 1954 by local businessmen who felt that the area could well benefit from an active service club. The membership has now grown to over 50 and they meet each Wednesday over lunch. This nonprofit organization sponsors several fundraising activities, such as the Paine Field Air Fair, to support their many and varied projects directed to the betterment of the south county community." (Courtesy of the Snohomish County Airport.)

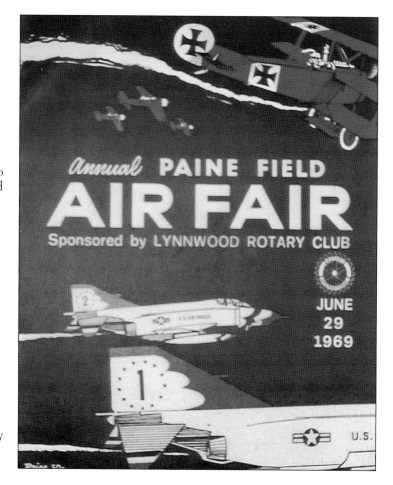

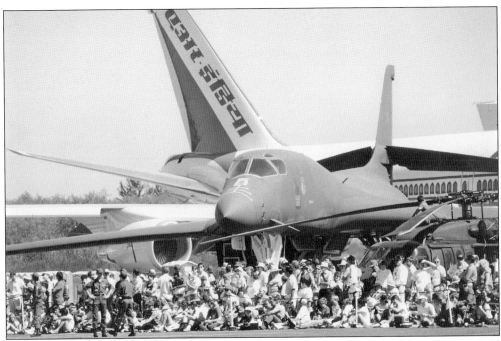

Former airport manager George Petrie said, "Prior to the Lynnwood Rotary Air Fair, Paine Field had air shows sponsored by the Everett Junior Chamber of Commerce [Jaycees] for a couple years; and then, the Everett Elks. When the Lynnwood Rotary took over, they expanded the event. The Lynnwood Rotary started bringing over the Russians. Charles Crum negotiated bringing the Russians over for the Lynnwood Rotary Air Fair. The Russians flew over in a huge transport. When they left, they filled the plane with American merchandise." In the foreground of this photograph is a Boeing B-1 Lancer. (Courtesy of the Snohomish County Airport.)

Since the earliest days of aviation, pilots have been entertaining crowds with their aircraft and acrobatic maneuvers. Barnstorming pilots had flown from town to town in the 1920s and 1930s, giving demonstrations. These demonstrations became air shows, which were very popular forms of entertainment. Due to popular demand, pilots and their aircraft were encouraged to develop new maneuvers to thrill the crowds. JETAIR used to be owned by Bruce and Craig McCaw, the wireless telecommunications pioneers, who left a big footprint on Paine Field. (Courtesy of the Snohomish County Airport.)

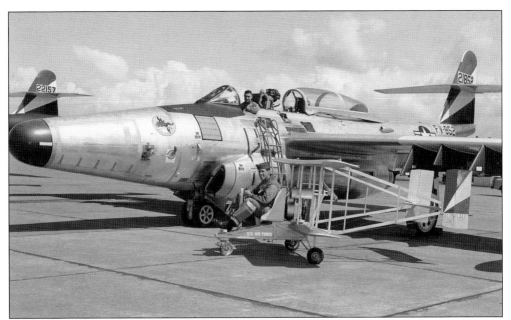

Between 1946 and 1967, the Everett Elks and Everett Jaycees sponsored air shows at Paine Field. During the 1950s and 1960s, Air Force personnel coordinated the show. The military played a key role in turning the show into a major summer event. People also enjoyed the static displays that the Air Force exhibited at the south complex of Paine Field. In the foreground is the base "mascot" plane in 1958. (Courtesy of the Snohomish County Airport.)

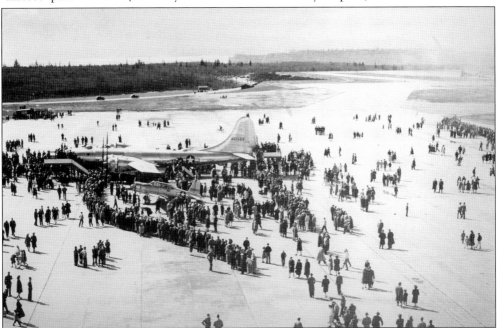

In 1967, the Everett Jaycees felt overwhelmed by the huge crowds coming to the air show. The roads were inadequate to handle such a large volume of traffic. Concessions ran out of food. Portable restrooms could not accommodate the crowds. As a result, the Jaycees decided to terminate its sponsorship of the air show. (Courtesy of the Everett Public Library.)

In 1969, the Lynnwood Rotary decided to sponsor the air show at Paine Field. During its 24 years of sponsoring the Washington State International Air Fair, over $1 million in profits were generated. From 1969 to 1992, 133 charitable organizations received grants from air fair proceeds. Hundreds of thousands of spectators were educated and entertained. Providing humanitarian service, 398 Rotarians and hundreds of volunteers generated funds to benefit various charitable projects. (Courtesy of the Snohomish County Airport.)

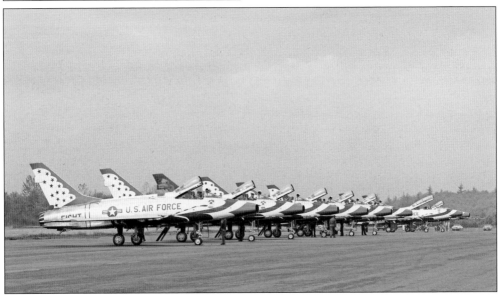

According to the Paine Field Air Fair program of June 29, 1969, "The United States Air Force Thunderbirds were activated in May 1953, to 'promote better understanding and appreciation of air power and to assist with the effective advancement of our national objectives.' In their 16-year history, the Thunderbirds have performed in more than 40 countries of the Free World, before more than 77 million spectators. This year the Thunderbirds are performing in the McDonnell Douglas F-4E Phantom II jet. These men are truly America's 'Ambassadors in Blue.'" Pictured above are the US Air Force Thunderbirds F-100s. (Courtesy of Jim Larsen.)

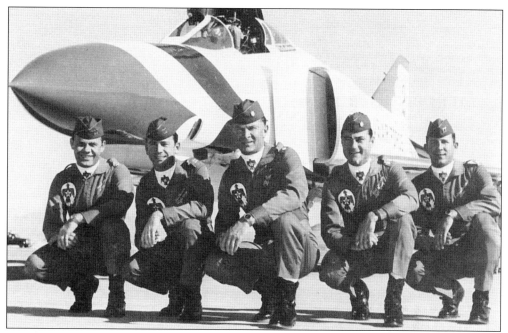

Based at Nellis Air Force Base in Las Vegas, Nevada, the Thunderbirds are the demonstration squadron of the US Air Force (USAF). They have performed solo and aerobatic formations in various aircraft at air shows throughout the world. The name is taken from legendary creatures that appear in the mythology of Native North American peoples. They have the reputation of being the "fastest flying (multiple jet) flight demonstration team in the world." Part of the USAF combat force, the Thunderbirds perform an average of 88 shows per year. Pictured above is an F-4 aircraft. (Courtesy of the Snohomish County Airport.)

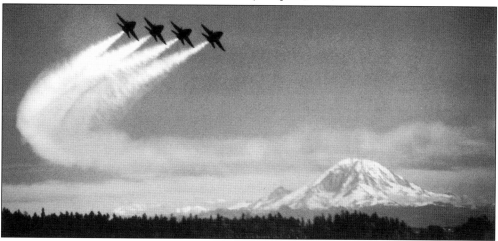

The Blue Angels is the flight demonstration squadron of the US Navy. Formed in 1946, it is the second-oldest flying aerobatic team in the world (the French Patrouille de France was formed in 1931). The Blue Angels fly in more than 70 shows at 34 locations throughout the United States each year, including at Paine Field. The six demonstration pilots fly the F/A-18 Hornet. From March to November, the Blue Angels pilots visit schools and hospitals. Since 1946, they have performed in front of more than 260 million spectators. Above, the Blue Angels fly over Lake Washington with Mount Rainier in the background. (Courtesy of the Snohomish County Airport.)

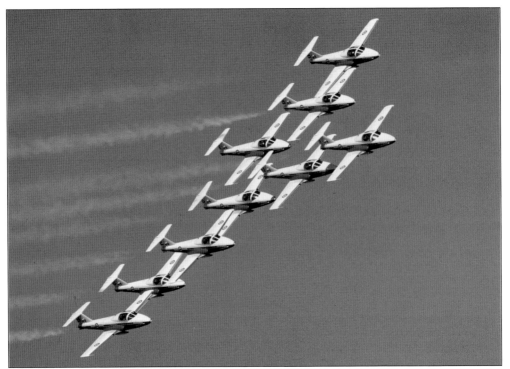

The Snowbirds is Canada's military aerobatics demonstration team. Known officially as the Royal Canadian Air Force's 431 Air Demonstration Squadron, its purpose is to demonstrate the teamwork, skill, and professionalism of Canada's military. Based in Moose Jaw, Saskatchewan, the Snowbirds fly the Canadair CT-114 Tutors. The show team consists of nine pilots. Approximately 80 military personnel work with the Snowbirds. The first Canadian air demonstration team to be designated a squadron, the Snowbirds is the only major military air demonstration team to perform without a support aircraft. (Courtesy of Jim Larsen.)

At Paine Field's air show in 1977, two planes collided, a result of poor weather. The pilots ejected over Possession Sound. A fisherman witnessed the incident and rescued the pilots. The Arvo Tudor planes, belonging to the Canadian Snowbirds, were later recovered from the sound. (Courtesy of the Snohomish County Airport.)

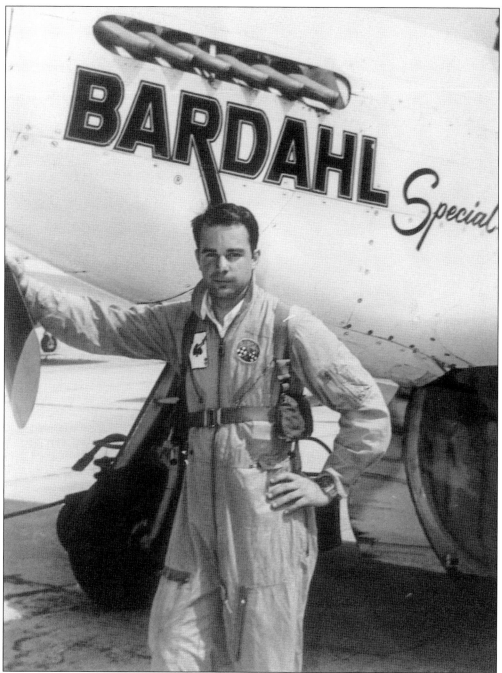

The following is an excerpt from the 1964 Lynnwood Rotary's International Air Fair program: "Charles A. 'Chuck' Lyford is a happy-go-lucky, fun and speed-loving soldier of fortune type, who could have come right out of a dashing romantic novel and is only 29 years old. Chuck has flown in every air show at Paine Field since 1961 using about a dozen different types of aircraft. This year he will be using Larry Blumer's World War II Lockheed P-38 and will also demonstrate the fantastic performance of the Gates Aviation Learjet, courtesy of Jet Air Corporation, Paine Field, Washington." (Courtesy of Charles Lyford.)

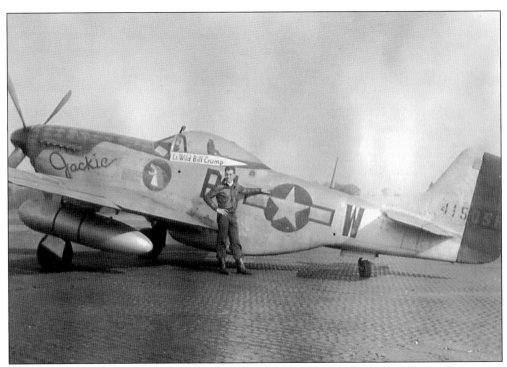

John William "Wild Bill" Crump was born on July 2, 1924, in the town of Opportunity, near Spokane, Washington. Bitten by the flying bug at an early age, Crump flew P-40s, P-47s, and P-51s during World War II. He served with the US Air Force for 23 years. Following his retirement, Crump became an air-show performer. (Courtesy of Bob Crump.)

Wednesday, June 15, 1988 **The Herald**

Civic activist wins MacArthur award

By Herald staff

EDMONDS — The Gen. Douglas MacArthur Award has been presented to Bill Crump, a retired Air Force lieutenant colonel.

The Lynnwood Elks made the presentation at the Memorial Day program sponsored by the South County Memorial Day Committee.

The award is given each year to citizens of south Snohomish County who have distinguished themselves by exemplifying the principles of Americanism cherished by MacArthur and advocated by the Elks.

Since his retirement from the Air Force in 1966, Crump has devoted many hours to community service projects.

As president of the Edmonds Rotary Club, he directed construction of the gazebo bandstand in the city park and helped establish the Rotary Lending Locker, which makes all types of convalescent equipment available to the needy free of charge.

He's been involved in establishing a sister city club in Wolfach, West Germany; starting the Frances E. Anderson Memorial Display in the Frances Anderson Center; and creating the Harry H. Kretzler Sr. Memorial Display and perpetual illuminated flag at the American Legion Hall in Edmonds.

As commander of the American Legion Post 66, Crump was responsible for erection of the Edmonds War Memorial and Wartime Exhibit at the Edmonds Museum.

He has been involved in starting the "Parade of Pioneers" to honor Edmonds senior citizens in all Edmonds parades and the Rosalyn Sumners Hall of Fame in the Edmonds Museum.

Crump has been honored as "Citizen of the Day" by KIXI radio.

For more than 10 years, Crump has donated the services of his aircraft,

providing local orientation flights to foreign exchange students and performing aerobatic shows throughout the Northwest in his airplane dubbed the "Spirit of Edmonds."

He is commander of the Edmonds Veterans of Foreign War Post 8870, vice chairman of the Edmonds Centennial Committee and on the fountain selection committee. Crump has been active in Memorial Day, Flag Day and 4th of July events.

Each year he performs a mini-airshow over the Edmonds waterfront just before the fireworks.

He also was recently appointed south county representative for the Northwest Freedom Foundation, a volunteer educational and patriotic organization that sponsors events to celebrate our freedoms and Americana heritage.

He also has been assigned as air operations officer for "Wings Over Washington," the state centennial event that will create multiple air

Bill Crump

shows and flying events to celebrate the 100th anniversary of statehood.

Crump is the 23rd recipient of the MacArthur Award.

With aeronautical ratings in single-engine, multiengine, and land and seaplanes, as well as ratings for gliders, helicopters, and jets, William Crump flew over 60 different aircraft. "He made it his mission to get people interested in aviation," said his son, Bob. Crump, a former airport commissioner, was often seen providing free rides to interested youth at the Paine Field Air Show, in the hope that they would pursue careers in aviation. The recipient of the prestigious MacArthur Award, Bill Crump died on February 8, 2008. (Courtesy of Bob Crump.)

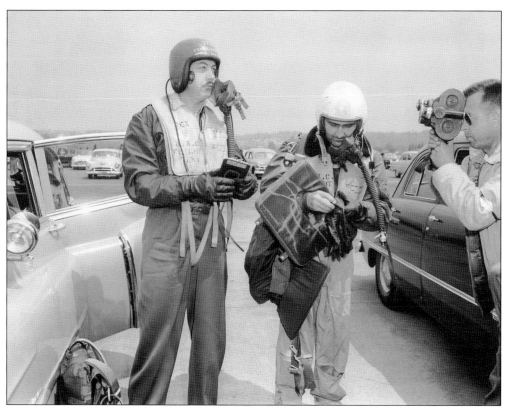

Alvin M. Johnston (left) earned the nickname "Tex" due to wearing a Stetson hat, cowboy boots, and string tie on the flight line. A test pilot, Johnston is known for performing a barnstorm-style, barrel-roll maneuver in front of 200,000 spectators above Lake Washington in a prototype Boeing 707. When asked by Bill Allen, then president of Boeing, why he pulled the stunt, Johnston replied, "I was selling airplanes." Johnston is also author of the autobiographical book *Tex Johnston: Jet-Age Test Pilot*. (Courtesy of the University of Washington.)

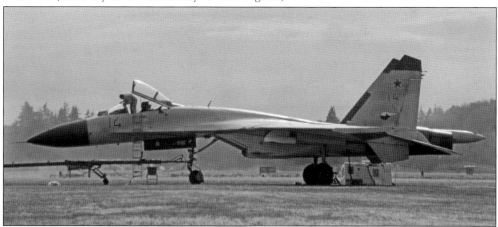

In the summer of 1990, the Goodwill Games were held in Seattle at the University of Washington. Along with Soviet athletes and dignitaries were Soviet pilots. Several Soviet aircraft refueled at Paine Field on their way to the Oklahoma City Air Show. Pictured above is a Russian MiG-29 like the plane owned by the Flying Heritage Collection. (Courtesy of Jim Larsen.)

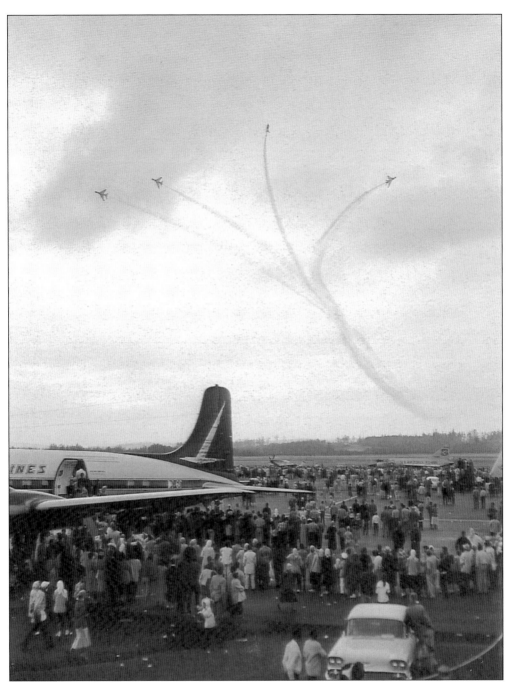

Don Bakken was appointed to the Snohomish County Airport Commission in 1966. In 1972, he was employed by the county and served on the Paine Field staff until his retirement as airport manager in 1992. The third airport manager, Bakken served in that role from 1980 to 1992. A charter member and past president of the Lynnwood Rotary Club, Bakken has been an aviation enthusiast all his life, and a pilot since 1945. In 2000, he published the book *Lomcevak! The Story of the Lynnwood Rotary International Air Fair.* This airshow at Paine Field was photographed in the 1960s. (Courtesy of the Snohomish County Airport.)

Seven

MODERN TIMES

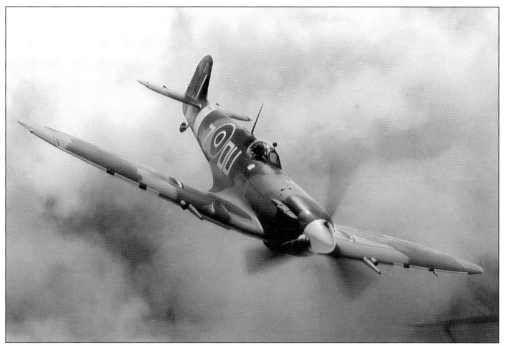

January 1, 1970, brought about a change in the way airports could do business. The National Environmental Policy Act took into consideration the impact of noise, traffic, and pollution that might occur at an airport, and its impact on the surrounding community. Residents suddenly had a big club to wield when it came to airport expansion and development. Shown above is Britain's Supermarine Spitfire Mk VC, which was used during World War II's Battle of Britain. (Courtesy of the Flying Heritage Collection.)

In the early 1970s, the county was providing over 100 businesses with low-rent opportunities at Paine Field. This "incubator" concept was a bright spot in the county's economy. "George Petrie, second airport manager, deserved much of the credit for the transfer of military property to civilian use," said Don Bakken. (Courtesy of the Everett Public Library.)

With the passage of the National Environmental Policy Act, the federal government wanted 5-year, 10-year, 15-year, and 20-year plans detailing an airport's growth and expansion. There was environmental input from citizens. A master plan determined funding and provided citizens with future airport plans. In 1973, Paine Field conducted a study to determine the future role and plan of Paine Field Airport. The study caught the attention of local environmental groups who were concerned about noise pollution. This photograph depicts airport construction near a designated wetlands area at Paine Field. Located between Mukilteo Speedway (SR525) and South Perimeter Road, this safety area project occurred in 1998. (Courtesy of the Snohomish County Airport.)

The issue at Paine Field boiled down to the difference between a small general-aviation airport and a major-carrier airport. The local citizenry was violently opposed to the latter. All studies conducted at Paine Field ended in an impasse; no agreement could be reached on the role of the airport. To this day, the issue continues to be a hot debate topic among special interest groups. Note the 747 in the background. (Courtesy of the Snohomish County Airport.)

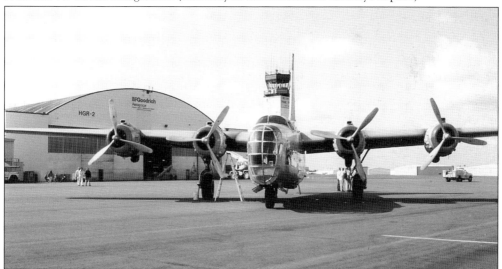

Throughout the 1970s, private business grew at Paine Field, and the county continued to purchase acreage. Several important events took place during this time. A Naval Reserve unit and National Guard training group from Sand Point arrived (1972–1973), and a new FAA control tower (Tower No. 2) was dedicated on October 31, 1973. Industrial activity boasted a reported $6 million in payrolls at Paine Field. The issue of a regional airport continued to be controversial in local politics. Pictured here is a Collings Foundation B-24. (Courtesy of the Snohomish County Airport.)

The FAA funded the Washington State Airport Plan in 1973. This plan addressed "aviation facility needs for the next 20 years." The document stated, "No new air carrier airport is foreseen for the Puget Sound region during the next twenty years." Paine Field and McChord Air Force Base were to be used to relieve congestion or fogged-in situations at Boeing Field or Sea-Tac. Paine Field, declared a "commuter-general aviation complex," was to be used as a backup airport. (Courtesy of the Snohomish County Airport.)

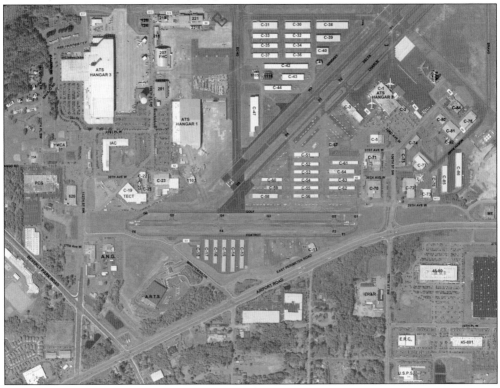

While plans for a "super airport" at Paine Field had been shelved, a new master plan (1973) focused on the "(1) accommodation-capability of handling large commercial aircraft, and (2) promoting the industrial park area and growth of 'non-aeronautical industrial and commercial activities at Paine Field.'" As Paine Field continued to grow, so did the surrounding community. Citizens would eventually play a key role in the future of Paine Field. The "Condo Hangars" shown at the top of this photograph are privately owned, but the land is leased for the Snohomish County Airport. (Courtesy of the Snohomish County Airport.)

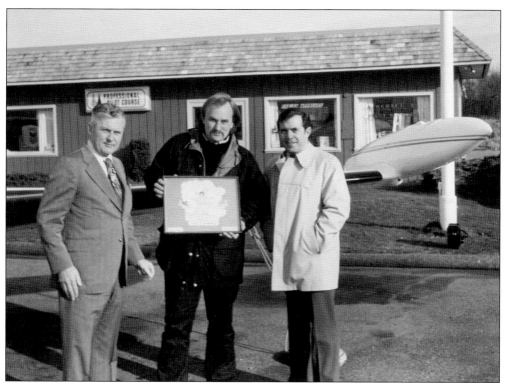

Pictured here are airport manager George Petrie (left), pilot Joe Freudenberg (center), and tower chief Charlie Crum in early 1975. Freudenberg is being presented with a certificate commemorating the fact he had just made the one-millionth landing at Paine Field since the FAA took control of the tower. In the background are a Cessna 310 and the Willard Flying Service building. (Courtesy of the Snohomish County Airport.)

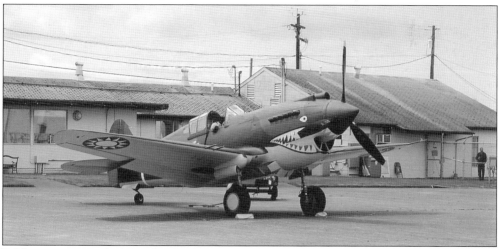

Public opinion reached new levels of concern in 1976. The opposition to an air-carrier airport focused on devaluation of property, increased noise, safety issues concerning large planes, as well as increased operations, runways, and flight lines. Public outcry would become the fifth and most complex barrier in Paine Field's attempts to develop a "super airport." Pictured here is the Flying Heritage Collection's P-40C. (Author's collection.)

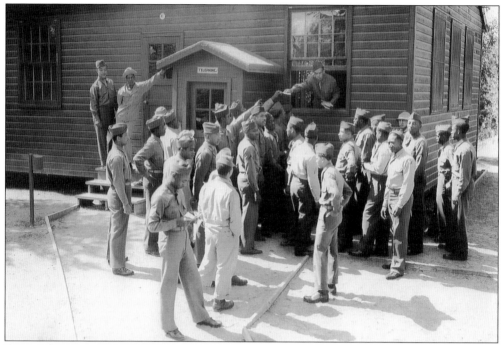

During the Army Corps and Air Force occupations in World War II, there was military barracks (pictured above), but few apartments or homes. With the building of the Boeing assembly plant in the mid-1960s, the population near Paine Field continued to grow significantly, and the growing community played a huge role in the airport's history. Several citizen interest groups participated in airport proceedings and were involved with Paine Field's planning and development committees. (Courtesy of the Snohomish County Museum of History.)

In 1978, the Airport Commission, Snohomish County Planning Commission, and public-interest groups began to explore new plans for Paine Field. The first proposal was called the "do nothing" plan. The second proposal called for "revised general aviation." The third proposal was called "air-cargo aviation" and promoted the replacement of service, maintenance, and hangar facilities. Finally, the fourth proposal supported a "super airport." It called for deactivation of light aviation and the establishment of a major air-carrier airport that would support commercial airline service. (Courtesy of the Snohomish County Airport.)

After careful scrutiny, the concerned groups settled into two camps. The Airport Commission supported the "air-carrier" proposal. The community favored the "general aviation and "do nothing" proposals. During the spring of 1978, the debate culminated with the planners submitting to the board of county commissioners (shown here) a proposal for "do nothing" and "revised general aviation" at Paine Field. The commission has included people like Willis Tucker, Lois Campbell, J.A. Whittaker, George Petrie, Ken Killien, Don Bakken, Dean Echelbarger, and Dave Helms. (Courtesy of George Petrie.)

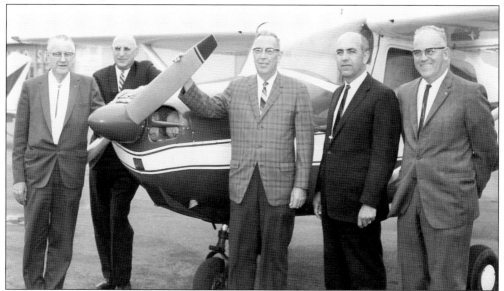

Factors that influenced the board of county commissioners' decision to pursue a "do nothing" and "revised general aviation" plan included the need for further environmental impact studies, protecting Boeing's usage rights, the expanding industrial park, and the "demand for improved and expanded light aircraft general aviation facilities in the Seattle-Tacoma-Everett region." A mediation committee was established at the University of Washington to "resolve differences that might arise between the operation of Paine Field and the surrounding community." (Courtesy of the Snohomish County Airport.)

113

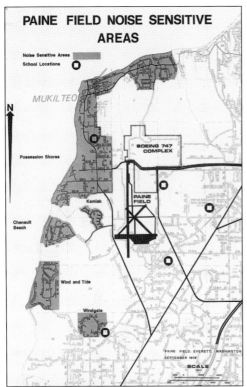

PAINE FIELD NOISE SENSITIVE AREAS

Noise-abatement procedures serve to minimize exposure of residential areas to aircraft noise. Recognizing that communities surrounding the airport, including homes, businesses, and schools, are noise-sensitive, Paine Field has put in place measures to minimize the impact on the community. Subject to air-traffic control and pilot discretion for safety reasons, the procedures address departures and approaches of small propeller aircraft, jet, turboprop, and large propeller aircraft, and rotary-wing aircraft. (Courtesy of the Snohomish County Airport.)

This photograph, taken on September 12, 1985, shows the second reunion of the 46th Air Service Squadron. The squadron was stationed at Paine Field during World War II. Shown here are, from left to right, (first row) Dickey, Leitzke, Brynes, Person, Rothas, Otto, and Englekardt; (second row) Egbert, Fields, Black, Jepson, Maroney, Helt, Kerber, Chartrand, Borders, Kennedy, Dicey, Figard, Stephenson, Clifton, and Schafer; (third row) Giordano, Cox, Smith, Newby, Van Why, Martin, Kahr, and Skillings (Courtesy of Steve Kerber.)

Between 1952 and 1985, the changes continued at Paine Field. Numerous galvanized, concrete-block, and metal hangars were constructed. New companies included Bill Marsten's Everett Aviation, Cal Aero Flying Service, Clayton Scott's Airco NW, Cascade Flying Club, Jet Deck Restaurant (shown here), Dicey Miller Flying Service, Ted Garrison's Used Aircraft Sales, Crown Aviation, Ron Morcum's Regal Air, Tom Chandler's TC Airmotive, and GTE Corporate Aircraft facilities No. 1 and No. 2. No longer in operation, the Jet Deck was a popular gathering place for people to dine and watch airplanes land and take off. (Courtesy of the Snohomish County Airport.)

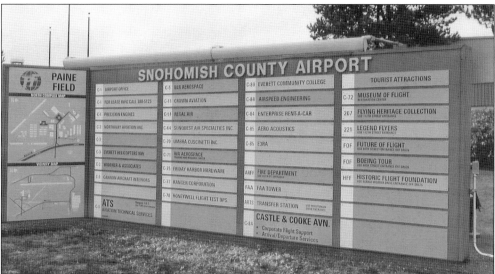

Other changes included the renaming of the former airlines maintenance hangars, located near the airport office, to Jet Air Hangar, Everett Community College Applied Technology School, Robertson Aircraft, Boundary Layer Research, Paine Field Instruments, UW Atmospheric Research, Boeing Employees Flying Club, Army Reserve Helicopter Unit, SLAPCO (Salt Lake Aircraft Parts Company), Gerald Snodey Maintenance, and Enstrom Helicopter. Today, Aviation Technical Services (ATS) is one of the largest aviation maintenance facilities in the nation. (Author's collection.)

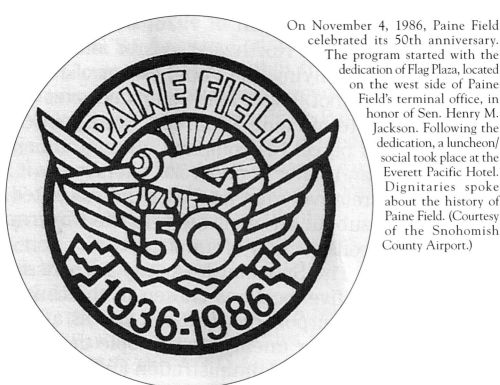

On November 4, 1986, Paine Field celebrated its 50th anniversary. The program started with the dedication of Flag Plaza, located on the west side of Paine Field's terminal office, in honor of Sen. Henry M. Jackson. Following the dedication, a luncheon/social took place at the Everett Pacific Hotel. Dignitaries spoke about the history of Paine Field. (Courtesy of the Snohomish County Airport.)

On July 28, 1987, Snohomish County Airport officially dedicated a new runway, 16L-34R. Construction began in 1985. The new runway was designed to "improve airport capacity, safety, and environmental mediation options and permit Paine Field to accommodate forecast aviation requirements in the Puget Sound region for the next twenty years." The project was funded in part by a grant from the FAA's Airport Improvement Program. Other projects over the years have included such things as the ground-breaking for the new control tower No. 3, which FAA and Snohomish County officials are gathered for in this photograph. (Courtesy of the Snohomish County Airport.)

The Army Reserve had a helicopter unit at Paine Field. The commanding officer of the unit, Col. Errol VanEaton, often flew the CH-47 twin-rotor Chinook helicopter (pictured above). The helicopters, which were often used to battle forest fires, carried 25,000 gallons of water. One day, while airport manager Don Bakken was driving his Dodge along the taxiway in communication with the airport tower, he heard the sound of VanEaton's helicopter. Suddenly, VanEaton came over the radio. "I think Bakken needs a car wash," he chuckled, dropping water on Bakken's vehicle. (Courtesy of the Snohomish County Airport.)

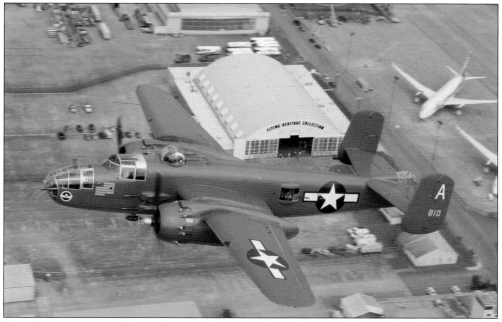

The Flying Heritage Collection (FHC), which opened at Paine Field in 2008, consists of 20th-century "warbirds" from Britain, Germany, Russia, Japan, and the United States. Acquired by Paul G. Allen, these "last-of-their-kind artifacts" were often gathered from historic battlefields and restored to the highest level of authenticity. Many of the aircraft have been returned to flying condition. Pictured above is the Flying Heritage Collection's B-25 Mitchell. (Courtesy of the Flying Heritage Collection.)

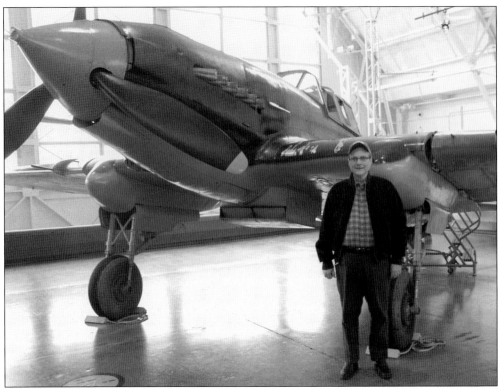

Paul Allen, cofounder of Microsoft, is the owner of Paine Field's Flying Heritage Collection, located in the former Alaska Airlines hangar. He is shown here standing in front of one of his vintage warbirds, the Soviet Ilyushin II-2M3 Shturmovik. Soviet pilots referred to it affectionately as the *Ilyusha*, which translates to "the winged tank." This is the most-produced military aircraft design in aviation history. (Courtesy of the Flying Heritage Collection.)

Art Unruh was a staff sergeant and waist gunner in the 15th Air Force, 301st Bombardment Group. He flew over 50 missions in World War II. Unruh entered service on February 2, 1943, and spent a night at Paine Field while a runway prop on his B-17 Flying Fortress was being repaired. Wounded in battle, Unruh was honorably discharged on September 7, 1945. The author of the book *The Shadow Casters: My Journey Through War*, the 90-year-old Unruh keeps himself busy as a public speaker and docent at Paul Allen's Flying Heritage Collection. (Author's collection.)

The Future of Flight Aviation Center and Boeing Tour opened on December 16, 2005, with a ribbon-cutting ceremony and speech by Gov. Christine Gregoire. The $23.5-million facility had the distinction of being "the only public tour of a commercial jet assembly plant in North America." Exhibits include a 727 cockpit, full-size airplanes, and an X-15 flight simulator. The Future of Flight Aviation Center and Boeing Tour generates in excess of $3.5 million annually in state tourism revenue. Bill LeWallen was project manager. (Author's collection.)

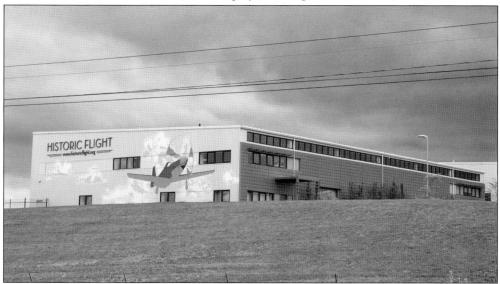

Established in 2003, the John T. Sessions Historic Flight Foundation opened with the intention to "collect, restore, and share significant aircraft from the period between the solo Atlantic crossing of Charles Lindbergh and the first test flight of the Boeing 707." Included in the collection are a B-25 D Mitchell "Grumpy," a P-51-B "Impatient Virgin," and a Tigercat F7F "Bad Kitty." (Author's collection.)

John T. Sessions became passionate about aviation following a visit to a flying club at Boeing Field in 1983. He started flying small Cessnas, graduated to bush planes, and then piloted corporate jets. Founder and chairman of the Historic Flight Foundation, Sessions is rated to fly most of the classic "warbirds" in his collection. (Courtesy of the Historic Flight Foundation.)

The Museum of Flight strives to acquire and preserve a variety of artifacts related to aviation and space history. Located at Paine Field, the restoration center utilizes dedicated volunteers who work to restore aircraft to "exhibition quality." In the 23,000-square-foot building (previously known as Robertson Aircraft), approximately 50 volunteers work on three to five projects at any given time. Visitors to the Restoration Center have the opportunity to walk among aircraft in a working hangar. This Grumman Wildcat is destined for the Seattle Museum of Flight. (Author's collection.)

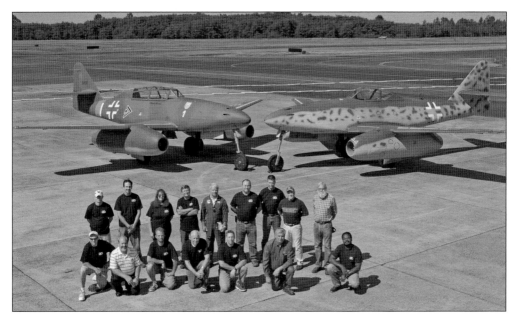

The Me262 Project is a company whose main purpose is to "build flyable reproductions of the Messerschmitt Me262." This German twin-engine plane was the world's first operational jet fighter. Based at Paine Field, the project team consists of technicians, engineers and designers known as the "Legend Flyers." Since 1999, they have occupied building 221, which previously served as the Air Force "alert" hangar, which housed fighters ready for instant dispatch. To date, the company has assembled five planes for such organizations as the Collings Foundation, Messerschmitt Foundation, and Evergreen Aviation Museum. (Courtesy of the Legend Flyers.)

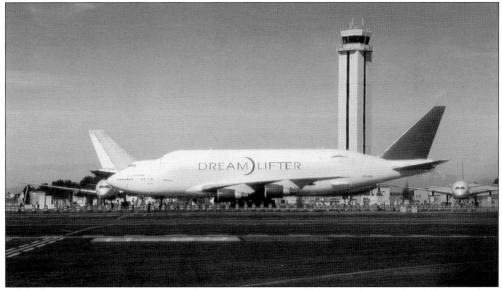

After three years of construction, the new Paine air-traffic control tower (No. 3) opened on Thursday, October 16, 2003. The new tower provides excellent visibility for air-traffic controllers. It stands nearly twice as high as the old tower (No. 2). Controllers are located approximately 178 feet above the ground. The official dedication of the tower took place on October 31, 2003. (Author's collection.)

David T. Waggoner graduated from the University of Washington with a bachelor of arts degree in international business and an NROTC commission as an ensign in the US Navy. During his 26-year career as a naval aviator, Waggoner flew the A-6 Intruder. His last assignment in the Navy was as the commanding officer of Naval Air Station Whidbey Island. Since 1992, he has been Snohomish County Airport director. (Courtesy of the Snohomish County Airport.)

Paine Field Airport has 456 general aviation hangars, of which Snohomish County leases 326. Depending on the type of hangar, wait time can be anywhere from six months to five years. Jim Fernandez, a retired Northwest Airlines pilot, houses his planes in Paine Field's west condos. Here, Fernandez stands on the wing of his Lake Amphibian plane. Besides being an avid flyer, he is a classic-plane collector. (Author's collection.)

Today, Paine Field has three runways. It sees heavy traffic and is suited to most types of aircraft. Runway 16L-34R celebrated its reopening on August 29, 2013. Bob Roetcisoender was the first pilot to use the new runway. Suitable for small aircraft, it is 3,000 feet long and 75 feet wide. (Courtesy of the Snohomish County Airport.)

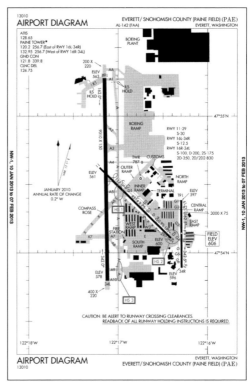

On December 4, 2012, the *Seattle Times* reported, "The Federal Aviation Administration approved passenger flights from Paine Field Tuesday, potentially transforming the general aviation airport into a small Sea-Tac competitor." Though local political leaders and the general community remain divided on this issue, 95 percent of the flights at Paine Field are general aviation. The other five percent are flights by Boeing jets. The second control tower constructed at Paine Field is visible in the background. (Courtesy of the Snohomish County Airport.)

Matt Stevens, wildlife biologist with the USDA Wildlife Services, strives to allow people and wildlife to coexist peacefully at Paine Field. Bird and other wildlife strikes cost USA civil aviation over $900 million per year. Wildlife strikes are on the rise, due to the fact that aircraft are faster, larger, and quieter. However, there have been fewer than 100 bird strikes over Paine Field in the past decade, due to Snohomish County Airport's Wildlife Management program. Stevens is seen here with a captured red-tailed hawk. (Courtesy of Matt Stevens.)

Father-and-son pilots Bud Granley, 76, of Bellevue and Ross Granley, 49, of Mill Creek lend their talents to fly World War II fighter airplanes, such as the North American P-51D Mustang and the Republic P-47D Thunderbolt from Paul Allen's Flying Heritage Collection. They perform at free Fly Days at Paine Field. Both Bud and Ross Granley served in the Royal Canadian Air Force. They also had careers as pilots for United Airlines. (Courtesy of the Snohomish County Airport.)

Precision Engines, previously Precision Airmotives, is Paine Field's oldest continuous tenant. Bill Monkman brought Precision Airmotives to Paine Field in 1964. The business changed names to Precision Engines in 1996. Occupying the 1950s building where Alaska Airlines used to overhaul engines, Precision Engines restores vintage radial Pratt & Whitney and Curtiss-Wright engines. (Courtesy of the Snohomish County Airport.)

Paine Field's oldest continuous noncommercial hangar tenant is Virgil Morgan, who currently keeps his Aerostar 601P aircraft in hangar C-64. Morgan has been a tenant of Paine Field since 1956. Most general-aviation hangars, like Morgan's, are leased or rented from Paine Field on a month-to-month basis. The east and west condo hangars and other private enterprises negotiate long-term leases for use of the ground. Long-term leases generally are for 35–55 years. At the end of a lease, buildings constructed by private enterprise revert to Paine Field ownership. (Courtesy of Virgil Morgan.)

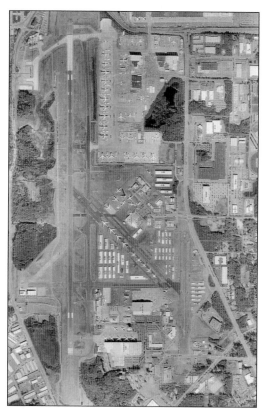

Paine Field is an enterprise of Snohomish County. Money made on the airport stays on the airport, which was a requirement of the deed from the US government when they gave the airport back to Snohomish County. All the buildings on Paine Field were inherited from the Air Force, built by Paine Field revenues, or built by private enterprise on Paine Field property. (Courtesy of the Snohomish County Airport.)

David Waggoner, Paine Field Airport director, is quoted in the *Mukilteo Beacon* of July 3, 2013, as follows: "Paine Field is currently in the midst of one of its busiest construction seasons in history. This year will see the completion of more than $60 million in new aerospace facilities. The airport is reconstructing the small parallel runway and a number of roads, as well as installing several new roofs this summer." The Dreamlifter Operations Center (DOC), pictured above, is currently leased from Snohomish County Airport by the Boeing Company. (Author's collection.)

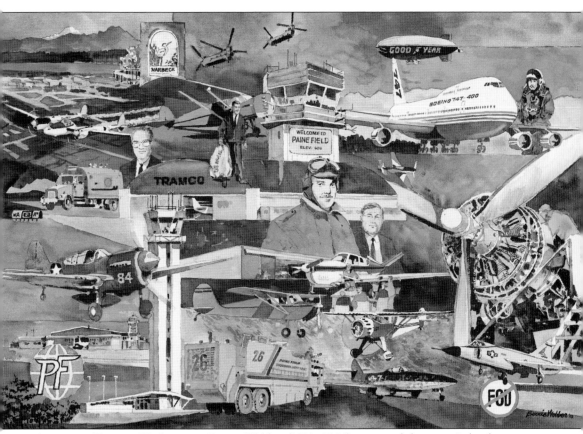

A native of Everett, Washington, Bernie Webber (1923–2006) preserved the region's development through his watercolor paintings. Webber drew for the Associated Sand & Gravel Company and Snohomish County Public Utility District. He also worked for the Port of Everett, which led to his employment with the Navy. A graduate of the Art Center School of Design in Los Angeles, Webber's watercolors capture the beauty and essence of the Pacific Northwest. Pilot, airport commissioner, and aviation enthusiast, Webber had a great fondness for Paine Field. An airport commissioner in the early 1980s, Webber is credited as one of the first to land his plane at Paine Field. Among other things, his drawings capture the unveiling of Everett's Boeing plant and test flights of the first 747. The Arts Council of Snohomish County named Bernie Webber Artist of the Year in 2004. Everett's internationally recognized artist was honored with the naming of Bernie Webber Drive at Paine Field's west entrance on October 16, 2010. This mural by Webber, depicting the history of Paine Field, hangs in the Snohomish County Airport office. (Courtesy of the Snohomish County Airport.)

DISCOVER THOUSANDS OF LOCAL HISTORY BOOKS FEATURING MILLIONS OF VINTAGE IMAGES

Arcadia Publishing, the leading local history publisher in the United States, is committed to making history accessible and meaningful through publishing books that celebrate and preserve the heritage of America's people and places.

Find more books like this at
www.arcadiapublishing.com

Search for your hometown history, your old stomping grounds, and even your favorite sports team.